IMAGES
of Rail

PITTSBURGH
STREAMLINED TROLLEYS

Best wishes

Kenneth C. Springirth

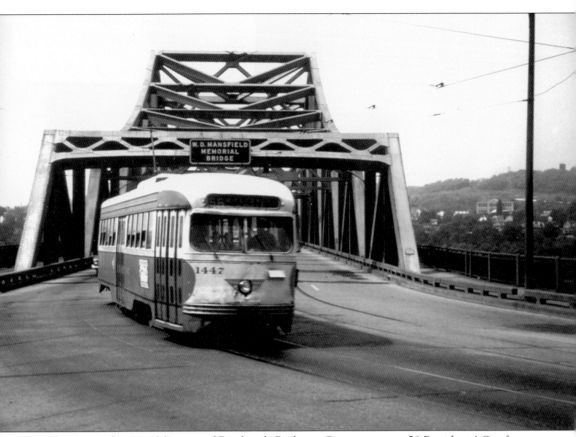

This September 11, 1961, view of Pittsburgh Railways Company route 56 Presidents' Conference Committee car No. 1447 turning off the W. D. Mansfield Memorial Bridge onto West Fifth Avenue heading for McKeesport offers a look back into the fascinating Pittsburgh trolley system. The Presidents' Conference Committee car was designed to be fast, smooth riding, and economical to maintain—all of which it accomplished in Pittsburgh. (Photograph by Kenneth C. Springirth.)

On the cover: The snowstorm of January 23, 1966, enhances the photograph stop on Cambronne Street and Winhurst Street for Presidents' Conference Committee car No. 1795, on a trolley car excursion operating over the Port Authority Transit system. Pittsburgh's North Side once offered an amazing variety of street-running, private right-of-way, and hill-climbing trolley car service. (Photograph by Kenneth C. Springirth.)

IMAGES
of Rail

PITTSBURGH
STREAMLINED TROLLEYS

Kenneth C. Springirth

ARCADIA
PUBLISHING

Published by Arcadia Publishing
Charleston SC, Chicago IL, Portsmouth NH, San Francisco CA

Printed in the United States of America

Library of Congress Catalog Card Number: 2006932454

For all general information contact Arcadia Publishing at:
Telephone 843-853-2070
Fax 843-853-0044
E-mail sales@arcadiapublishing.com
For customer service and orders:
Toll-Free 1-888-313-2665

Visit us on the Internet at www.arcadiapublishing.com

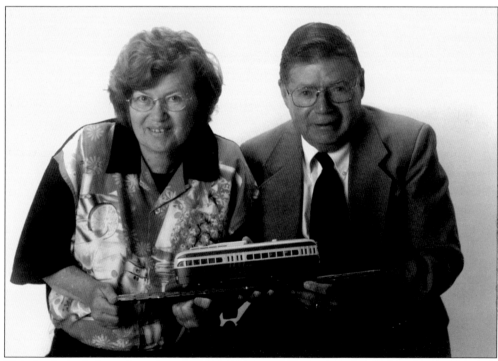

This book is dedicated to the author's wife, Virginia Springirth, who has over the years participated in the research projects for this series of trolley books. Virginia and Kenneth Springirth are viewing an O-gauge model, similar to Presidents' Conference Committee car No. 1713 of Pittsburgh Railways Company. This type of trolley car provided excellent public transportation service for Pittsburgh.

CONTENTS

ACKNOWLEDGMENTS

Frank Julian Sprague (born July 25, 1857, died October 25, 1934) was the father of the trolley car. He formed the Sprague Electric Railway and Motor Company that completed a 12-mile electric trolley line in Richmond on February 2, 1888, with 10 trolleys in operation. This was the first practical system. Gear locking, commutator, and brush problems had to be corrected, but by May 4, 1888, the Richmond system had 30 cars in operation. Laboring under enormous difficulties, Sprague succeeded in establishing the future growth of electric street railway systems. The Sprague system used in Richmond became an industry standard that was used in the majority of new trolley systems. His vision and technical ability brought together the best features of all the systems that had been devised. Electrified street railway trackage in the United States grew from 1,200 miles in 1890 to 22,000 miles in 1902 and to 48,000 miles by 1917. The Sprague system has survived cataclysmic policy changes that have taken place and is embodied in the design of many new light-rail systems. The trolley car is now back on track. Its passenger appeal and economic development potential have resulted in the reintroduction of trolley lines, using equipment that ranges from vintage to modern. *Street Railway Journal, Electric Railway Journal, Electric Railroaders' Association Headlights, Pittsburgh Post Gazette, Pittsburgh Press*, and the Carnegie Library of Pittsburgh Reference Department were major sources of information. W. K. Foster, B. H. Nichols, and Edwin A. Wilde provided pictures. My parents, Clarence and Sallie Springirth, taught me an appreciation for public transit and the importance of handling details, which is a necessary part in writing a book. My father was a trolley car motorman in Philadelphia and went to work with his uniform cleaned and pressed, and his shoes always had a military shine. He, like his associates, served as a combination guide, host, salesman, and public relations professional during his outstanding years of guiding trolley cars through the labyrinth of city traffic. My mother was a very practical, resourceful person who would always have dinner ready to meet dad's work schedule.

INTRODUCTION

In March 1888, the Pittsburgh Knoxville and St. Clair Street Railway opened a one-and-a-half-mile line, using a small electric locomotive that towed a passenger car. The line operated from Thirteenth and Carson Streets and used a steep trestle to reach the Allentown and Mount Oliver sections of Pittsburgh. By 1896, there were 337 miles of electric trolley track. The 1893–1894 business depression provided the impetus to many Pittsburgh-area trolley companies to merge. On January 1, 1902, all the Pittsburgh trolley companies were merged into the Pittsburgh Railways Company.

By 1914, the Pittsburgh Railways Company operated about 1,000 trolley cars. Rapid increases in labor and material costs occurred during World War II, plus an unusually severe winter during 1917 that resulted in the company not being able to meet interest payments on a number of bond issues, and it went into receivership on January 1, 1918. During receivership, there was a partial rehabilitation of track and roadbed. Receivership ended on February 1, 1924. A 10-year contract worked out with the mayor and council of the city of Pittsburgh provided for a Traction Conference Board, which functioned with railway management to reflect the public point of view on service and fare questions. On June 1, 1925, a $1.50 weekly pass was started, which reduced the basic fare of 10¢, or three tokens for 25¢, which averaged to about 5.25¢ per ride. The October 12, 1925, issue of *The Transit Guest*, published weekly by Pittsburgh Railways Company, noted that it was "awarded the Charles A. Coffin Foundation prize, the highest honor in electric railway circles." The company was honored because of its success in gaining public goodwill, implementing new operating and maintenance practices, and reducing the cost of obtaining new capital.

In 1932, discussion and design work focused on a new type of streamlined trolley car. Known as the Presidents' Conference Committee car, it was a four-year project of construction and testing, with many different transit systems involved. This car design became the best type of trolley ever to be placed in city transit service because of its comfortable seats, phenomenal acceleration, and ability to ride like a magic carpet, even on imperfect track. The Pittsburgh Railways Company received its first Presidents' Conference Committee car No. 100 on July 26, 1936. "Crowds Rush for Free Ride on New Trolley" was the caption in the *Pittsburgh Post Gazette* for Friday, August 28, 1936, which reported, "Officials and citizens agreed the rubber-wheeled car is the last word in comfort, safety, and fast, quiet service." The article continued, "The free trips for the public will continue for two weeks every day except Saturday, starting at 11:30 o'clock (in the morning) from Grant Street and Liberty Avenue, and making about three trips an hour until 3 o'clock (in the afternoon)." The Pittsburgh Railways Company advertisement in the *Pittsburgh Post Gazette* of Tuesday, January 12, 1937, declared, "The Streamline Trolley Demonstrator Goes into Regular Service Tonight." The car operated on route 38 from 7:12 p.m. until midnight and then became the night car for route 42. During the daytime, the car was on route 38 for operator training and did not pick up passengers.

This was the first Presidents' Conference Committee car placed into revenue service in the United States. The first 100 Presidents' Conference Committee cars (Nos. 1000–1099) were delivered during 1937.

"Trolleys File in Bankruptcy" was the headline in the *Pittsburgh Press* for Tuesday, May 10, 1938, that announced, "Pittsburgh Railways Company and its subsidiary Pittsburgh Motor Coach Company today filed a petition in Federal Court asking permission to reorganize under bankruptcy laws." On June 14, 1938, Thomas M. Benner, W. D. George, and Thomas Fitzgerald were named trustees to manage the Pittsburgh Railways Company and the Pittsburgh Motor Coach Company. That proceeding lasted until December 29, 1950, when the United States District Court ordered the reorganization trustees to turn over all properties to the new Pittsburgh Railways Company on January 1, 1951.

The *Pittsburgh Post Gazette* of Tuesday, February 17, 1942, noted that 100 more of these new cars were arriving, with the first 3 cars assigned to route 77/54 Northside, Carrick, and Bloomfield.

"Pittsburgh Railways Spends $2,835,000 for 100 Streamline Trolleys" was the headline in the *Pittsburgh Press* of Tuesday, December 7, 1948. The article noted that the new group of trolleys cost $28,350 each. That was almost twice the cost of the first streamlined trolleys, which were bought by the company in 1936, at a cost of $15,715 each, or $1,571,500 for the group of 100 cars. This was the final order, and the Pittsburgh Railways Company now had 666 Presidents' Conference Committee cars obtained at a total cost of $12,346,000. These 1700 series cars were redesigned from earlier cars. The windows were sealed and could not be raised or lowered. Four large overhead fans, which were concealed in the ceiling and evenly spaced down the car center, took fresh air from a long cowl on the roof and forced it through louvers, which directed it to all parts of the car. Dash lights were installed on the front of the car, to give the operator better night vision. This was an all-electric car with brakes, doors, windshield wipers, and sanders; all car accessories operated electrically. Special trucks, headlights, and cowcatchers were added to 25 of the new cars, which were specifically designed for use on the interurban trolley lines.

In 1950, the Pittsburgh Railways Company had 1,187 trolley cars, which declined to 1,078 trolley cars by November 16, 1952. The Charleroi line was cutback to Library Loop on June 28, 1953. The Washington line was cut back to Drake Loop on August 29, 1953. By July 1954, all service was provided by Presidents' Conference Committee cars. Early Sunday morning, June 21, 1959, all of the West End routes were converted to bus operation.

Ridership grew during World War II, and the yearly figures were as follows: in 1940, a total of 159,126,191; in 1941, a total of 172,500,720; in 1942, a total of 213,910,001; in 1943, a total of 274,820,071; in 1944, a total of 277,545,056; in 1945, a total of 279,998,372; in 1946, a total of 275,525,709; and in 1947, a total of 288,962,016. Yearly ridership then declined, as follows: in 1948, a total of 278,323,341; in 1949, a total of 254,075,897; in 1950, a total of 220,715,487; in 1951, a total of 191,830,870; in 1952, a total of 169,051,065; in 1953, a total of 153,949,293; in 1954, a total of 108,009,827 (35-day strike); in 1955, a total of 110,974,676; in 1956, a total of 106,112,834; in 1957, a total of 85,483,662 (55-day strike); in 1958, a total of 84,706,185; in 1959, a total of 80,201,489 (6-day strike); in 1960, a total of 75,845,639; in 1961, a total of 70,592,000; and in 1962, a total of 66,513,000.

On March 1, 1964, the Port Authority of Allegheny County took over Pittsburgh Railways, 30 bus companies, and the Duquesne and Monongahela Incline Plane companies. On July 5, 1964, trolley route 55 East Pittsburgh and route 58 Greenfield were converted to bus operation. Trolley car service between Avalon Loop and Emsworth was discontinued on December 31, 1965.Trolley routes 8, 10, 11, 15, 65/55, and 77/54 were converted to bus operation on September 5, 1965. Trolley route 50 Carson Street was converted to bus operation on February 27, 1966, followed by route 6/14 Avalon on May 1, 1966, and route 85 Bedford on June 26, 1966. All trolley car service ended on the North Side when route 21 Fineview car No. 1646 made its last trip over the Ninth Street Bridge on Sunday, May 1, 1966. The last 10 East End trolley routes (route 64 East Pittsburgh, route 66 Wilkinsburg via Forbes, route 67 Rankin-Braddock, route 71 Negley, route 73 Highland Park, route 75 Wilkinsburg via East Liberty, route 76 Hamilton, route 82 Lincoln, route 87 Ardmore, and route 88 Frankstown) were converted to bus operation on January 28, 1967. Car No. 1734 was the last trolley in regular

service on the East End, leaving Jane Street Loop at 5:15 a.m. on route 88 Frankstown. On Saturday, January 28, 1967, the borough of Wilkinsburg chartered car No. 1767 and gave free rides from 10 a.m. to 4 p.m. Trackage was kept in place to reach Homewood Shops. March 29, 1968, was the last day of operation for weekday peak-hour trolley route 47 Carrick via Tunnel, which was replaced by trolley route 53 Carrick. On March 31, 1968, trolley route 48 Arlington was replaced by an extension of bus route 54A Arlington Heights.

Saturday, June 28, 1969, was the last day trolley car route 44 Knoxville looped around the Greyhound bus terminal. Route 44 cars began looping from Smithfield Street to Liberty Avenue to Wood Street, which meant that Penn Avenue would be without trolley cars for the first time since the beginning of street railways in the 1800s. On Sunday, November 14, 1971, trolley route 44 Knoxville, route 49 Beltzhoover, and route 53 Carrick were converted to bus operation. On November 13, 1971, car No. 1727 made the last run on route 44, car No. 1733 made the last trip to the Chalfont Street Loop of route 49, and car No. 1762 made the last trip to the Brentwood Loop of route 53. A 49 Arlington-Warrington to South Hill Junction route was established to serve as a tunnel bypass route.

On Wednesday, July 26, 1972, the Port Authority Transit gave free rides on the first four brightly painted "mod" colors trolley cars using Grant Street, Liberty Avenue, Wood Street, and Fourth Avenue as the downtown loop. One car was painted white and yellow, one car was painted white and orange, one car was painted white and red, and one car was painted in a psychedelic design, with an orange rising sun on a field of yellow and purple. The idea was to give visual appeal to public transit. On Friday, November 21, 1975, regular bus service began running through the Mount Washington Trolley Tunnel. A controversial Skybus system had been proposed for the South Hills area, but a March 4, 1976, report from the consulting firm of the De Leuw, Cather, and Company recommended light-rail transit.

To celebrate the United States bicentennial, the Port Authority Transit operated vintage trolley car No. 3756 for 10¢ a ride on the downtown loop of Grant Street, Liberty Avenue, Wood Street, and Fourth Avenue on Friday, July 2, 1976, and continued each day, until its last run was made on Monday, July 5, 1976.

The *Pittsburgh Post Gazette* of May 8, 1979, reported that Port Authority Transit received $265 million to build a light-rail system from downtown Pittsburgh to South Hills Village. On December 10, 1980, there was a groundbreaking behind South Hills Village Mall for the new maintenance facility, which was the first step in rebuilding the trolley routes in the South Hills area into a new light-rail transit system. There were 55 new light-rail vehicles ordered from Siemens of Krefeld-Uerdingen, Germany, with final assembly at Blaw Knox Company in Allegheny County. Digging for the new 1.1-mile downtown Pittsburgh subway began on January 5, 1982, at Sixth Avenue, Seventh Street, and Liberty Avenue.

Around midnight on April 14, 1984, route 42/38 Mount Lebanon via Beechview made its last run, concluding Mount Lebanon's trolley day celebration that featured free afternoon rides on a special shuttle trolley, courtesy of the Washington Road Business and Professional Association. That was the last day of trolley car operation on Washington Road, as bus service was substituted during construction of a new trolley tunnel under Washington Road. The first trolley rolled out of the new $26 million South Hills Rail Center on April 15, 1984, and made its first stop as a route 47L car at South Hills Village Station at 5:27 a.m. Trackage south of Castle Shannon had been closed since August 1982, and the Castle Shannon–South Hills Village main line section was built under a $10.3 million contract and consisted of 2.8 miles of continuous welded double track. From the Drake line, there was a 0.4-mile spur built to South Hills Village Station. On July 3, 1985, the new downtown subway opened with governmental, civic, and business leaders making the first ride across the Monongahela River from Station Square to Steel Plaza Station, followed by free rides for the public. From July 3 through July 6, 1985, nearly 250,000 persons received a free ride on the new downtown subway between three underground stations (Gateway, Wood Street, and Steel Plaza) and Station Square. On July 7, 1985, Presidents' Conference Committee trolleys began using the new downtown subway, which after a subway contest became known as the "T" on August 23, 1985.

Service on route 52 Allentown was suspended for the reconstruction of Arlington Avenue during November 1986. The work had to be done in three phases, because the city could not afford to do it all at once. In June 1988, the Penn Park subway station opened. The rebuilt Library line was opened in December 1988. Route 52 Allentown service resumed on May 17, 1993. On June 6, 1993, a repair project closed the South Hills Tunnel for five months, detouring routes 42S South Hills Village and 47L Library trolleys via a 1.8-mile bypass over Warrington and Arlington Avenues. Service between Castle Shannon and downtown Pittsburgh on the 47 and 47S trolley cars was replaced with the 49 Shannon Overbrook buses that used Highways 51 and 88 because of the deteriorating condition of bridges. Presidents' Conference Committee cars were now confined to route 47D Drake Shuttle, which now only operated between Drake Loop and Castle Shannon.

September 4, 1999, was the end of Presidents' Conference Committee trolley service, and the route 47D Drake Shuttle was converted to bus operation. The First Avenue subway station was opened during November 2001. On June 2, 2004, the 5.2-mile reconstructed Overbrook line opened, and the first of 28 new light-rail vehicles built by Construcciones Y Auxiliar de Ferrocarriles S.A. (CAF) of Beasain, Spain, were placed in service.

Currently there are 83 light-rail vehicles, and the first 55 cars are being completely rebuilt by CAF at its United States plant in Elmira, New York, using only the body shell. Component parts will be similar to those used on the 28 cars built by CAF. Currently there are four lines: route 42S South Hills Village via Beechview, route 47S South Hills Village via Overbrook, route 47L Library via Overbrook, and route 52 Allentown.

One

SYSTEM GROWTH AND DEVELOPMENT

The pioneer of successful electric trolley operation from a technical and financial viewpoint was the Second Avenue line, which began operation from Market Street and Fourth Avenue in downtown Pittsburgh to Glenwood in March 1890. The Pittsburgh Railways Company, formed January 1, 1902, by a merger of a number of companies, was very innovative and constantly sought ways to improve its trolley cars. Cars Nos. 4000–4079 were completed by J. G. Brill Car Company in 1910 and became the standard high-floor, pay-as-you-enter car with a weight of 46,000 pounds. Patents were granted to P. N. Jones, general superintendent of Pittsburgh Railways Company, on the front and rear platform door operating mechanisms. The car bodies were steel below the windows, with wood used for window posts and roof framing. Cars Nos. 4100–4149, built by Pressed Steel Car Company during 1911, were similar to the 4000 series cars but were all steel. The St. Louis Car Company built the first production low-floor cars Nos. 4200–4249 in 1914. Under the direction of F. R. Phillips, superintendent of equipment, and P. N. Jones, general superintendent of the Pittsburgh Railways Company, a smaller-diameter motor frame with a longer frame length that made it possible to reduce wheel diameter was developed, thereby reducing the distance from the car floor to top of rail and making a low-floor car possible. Double-deck trailer car No. 6000 was built by the Pittsburgh Railways Company for experimental purposes and made its trial run on August 4, 1912. During 1913, five additional double-deck trolleys were ordered but were all burnt by 1927. Osgood Bradley Car Company built three experimental cars. Car No. 6000 had Westinghouse model 1426 motors, Westinghouse HB control, and weighed 36,500 pounds. Car No. 6001 had Westinghouse model 1425 motors, Westinghouse VA control, and weighed 35,000 pounds; both car No. 6000 and 6001 were built in 1928 with steel bodies. The third experimental car, car No. 6002, was built in 1929 with an aluminum frame and shell, Westinghouse model 1426 motors rated 50 horsepower, and Westinghouse VA control. According to the *Electric Railway Journal* magazine, volume 73 of 1929, this car weighed 27,000 pounds and had Timken Detroit Axle Company No. 52 worm drive trucks with disk brakes.

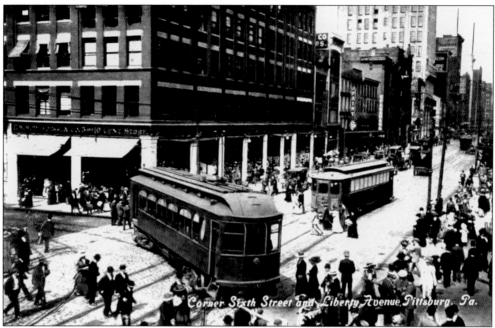

A Pittsburgh Butler and New Castle Railway Company interurban trolley car has turned the corner of Sixth Street and Liberty Avenue in downtown Pittsburgh, heading north in this postcard scene. By November 24, 1908, Pittsburgh was connected to Butler, Ellwood City, and New Castle by trolley car. This interurban trolley system made its last run on August 15, 1931.

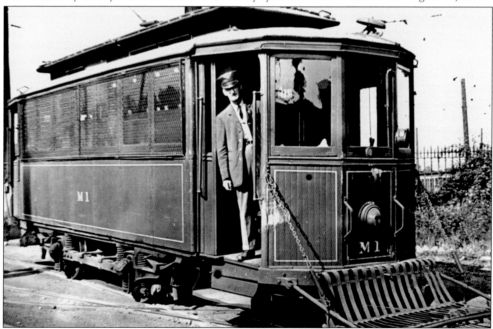

Car No. M1 was built in 1890 by the Pullman Palace Car Company for the United Traction Company of Pittsburgh. In 1897, this car was converted into a traveling payroll car and would travel to each car house to pay employees. This car has been preserved at the Pennsylvania Trolley Museum. (Photograph by W. K. Foster.)

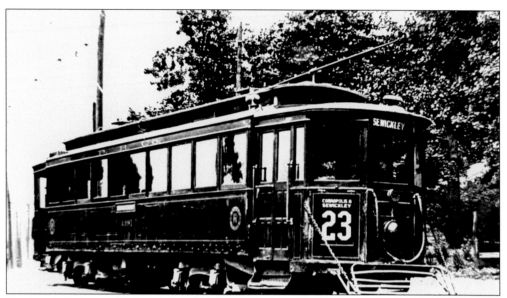

Pittsburgh Railways Company car No. 3391 was one of the 10 cars in the series 3390–3399 built by the St. Louis Car Company in 1908. This double-truck, double-end, closed wooden car had Westinghouse model 93 motors and St. Louis type 47-A trucks. Route 23 Sewickley was abandoned in 1952 because of a bridge replacement. (Photograph by W. K. Foster.)

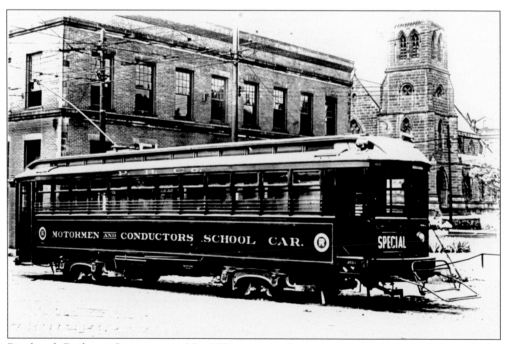

Pittsburgh Railways Company car No. 3550 was one of two experimental cars built by the Niles Car Company in 1909. It had two Westinghouse model 303 motors with side rods that were later replaced by four Westinghouse model 93 motors without the side rods. It was used as an instruction car after 1921 and scrapped in 1932. (Photograph by W. K. Foster.)

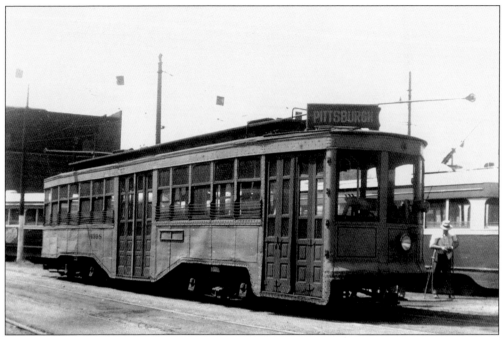

Pittsburgh Railways Company car No. 4398 is waiting for the next assignment at Glenwood Car House in this 1956 scene. The double-end car was in number series 4350–4399, built by the St. Louis Car Company in 1917, and had a low-floor design with fewer steps for boarding and exiting passengers. This car has been preserved at the Pennsylvania Trolley Museum. (Photograph by Edwin A. Wilde.)

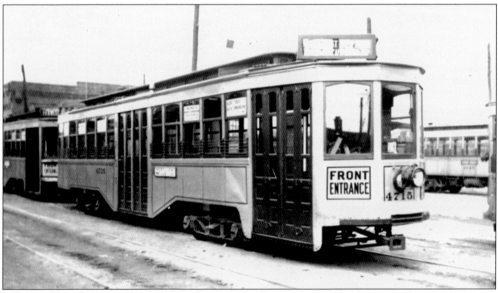

Pittsburgh Railways car No. 4715 is at Keating Car House in 1935. This car was in number series 4700–4799, built by the Cincinnati Car Company and delivered from August 1916 to August 1918. Weighing 33,200 pounds, the car was powered by four Westinghouse model 514A motors. Most of these cars were scrapped in 1942, during delivery of the 1400 series Presidents' Conference Committee cars. (Photograph by B. H. Nichols.)

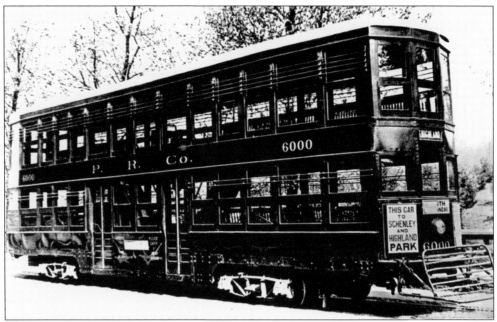

Pittsburgh Railways Company built car No. 6000 in 1912 as a double-deck trailer car. It was motorized in 1913 with four Westinghouse model 247 motors. The McGuire Cummings Car Company built five additional double-deck trolleys, car Nos. 6001–6005, in 1914. Car No. 6000 was scrapped in 1925, and the five remaining double-deck trolleys were scrapped in June 1927. (Photograph by W. K. Foster.)

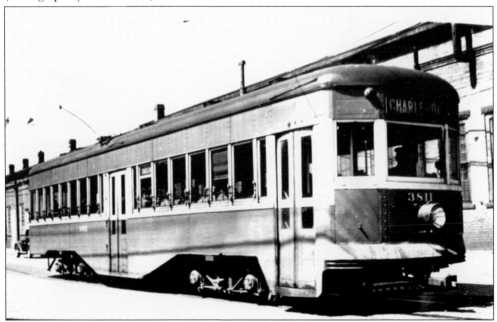

Car No. 3811 was in the series of car Nos. 3800–3814, built by the St. Louis Car Company in 1928. These cars had four Westinghouse model 535A motors and Westinghouse HL control. This series of cars was scrapped during the time period 1948–1952, having been replaced by the 1700-series Presidents' Conference Committee cars. (Photograph by W. K. Foster.)

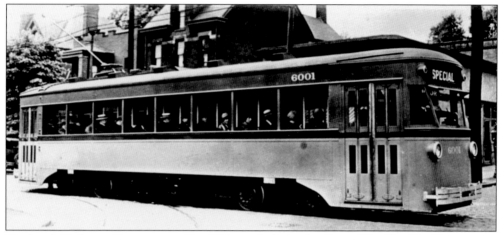

Pittsburgh Railways Company car No. 6001 was built by the Osgood Bradley Car Company in 1928 with Westinghouse model 1425 motors, Westinghouse VA control, Timken Detroit model 51 trucks, and a steel body. It weighed 35,000 pounds and had seating capacity of 35. The steel car body was 43.5 feet long. (Photograph by W. K. Foster.)

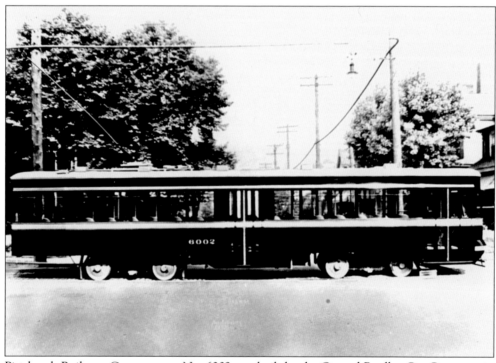

Pittsburgh Railways Company car No. 6002 was built by the Osgood Bradley Car Company in 1929 with Westinghouse model 1426 motors, Westinghouse VA control, and a maximum speed of 45 miles per hour. Until the advent of the Presidents' Conference Committee car in 1936, this was the fastest car in the Pittsburgh Railways Company fleet. (Photograph by W. K. Foster.)

Two

PRESIDENTS' CONFERENCE COMMITTEE TROLLEYS

As automobile ownership increased and a major depression hit the country, transit ridership declined in Pittsburgh and throughout the United States. The Pittsburgh Railways Company joined with other transit companies in organizing the Electric Railway Presidents' Conference Committee, which developed the Presidents' Conference Committee streamline trolley that was quiet, fast, and had comfortable seating. In North America, 4,978 of these cars were built. Pittsburgh Railways purchased 666 of these trolleys from the St. Louis Car Company; this was the third-largest fleet of Presidents' Conference Committee cars in North America. Toronto, with 745 cars, had the largest fleet, followed by Chicago, with 683 cars. Car No. 100 was received on July 26, 1936, cars Nos. 1000–1099 were received during 1937, cars Nos. 1100–1199 were received by 1938, cars Nos. 1200–1299 were received during 1940, cars Nos. 1400–1499 were received during 1942, cars Nos. 1500–1564 were received by 1945, cars Nos. 1600–1699 were received by 1946, and cars Nos. 1700–1799 were received by 1949. On May 9, 1952, trolley route 24 Schoenville was abandoned. Trolley routes 2 Etna and 3 Millvale were converted to bus operation on August 31, 1952. Trolley route 29 Thornburg was converted to bus operation on November 16, 1952. On June 28, 1953, the Charleroi interurban trolley line was cut back to the border of Allegheny County. On August 29, 1953, the Washington interurban trolley line was cut back to the border of Allegheny County. Trolley route 63 Corey Avenue ended service on August 23, 1953. Car No. 1695 made the last trip on trolley route 1, and car No. 1677 made the last trip on trolley route 5 as buses took over both routes on Sunday, October 6, 1957. West End trolley lines were converted to bus operation on June 21, 1959. On November 12, 1961, trolley routes 18 Woods Run and 19 Western Avenue were abandoned. By 1961, 100 Presidents' Conference Committee cars had been scrapped. Following strong winds that heavily damaged the borough of Glassport, the Pittsburgh Railways Company turned over operation of trolley route 98 Glassport to Noble J. Dick Bus lines effective August 3, 1963. Route 56, the last intercity trolley line in western Pennsylvania, was converted to bus operation on September 1, 1963.

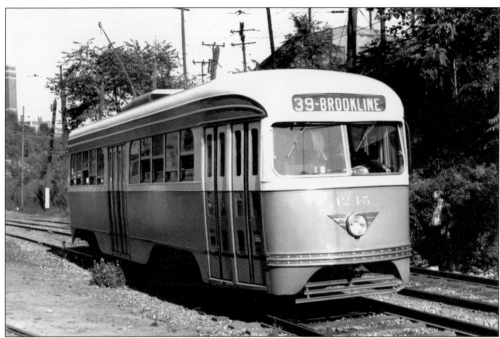

When the Michigan Railroad Club conducted a weekend trip to Pittsburgh on September 22, 1940, the Pittsburgh Railways Company's new President Conference Committee cars, like car No. 1245 passing through South Hills Junction, were perfect for photography. Cars Nos. 1200–1299 were delivered during 1940. These cars had a wraparound front bumper, and the front destination sign was not split. (Photograph by B. H. Nichols.)

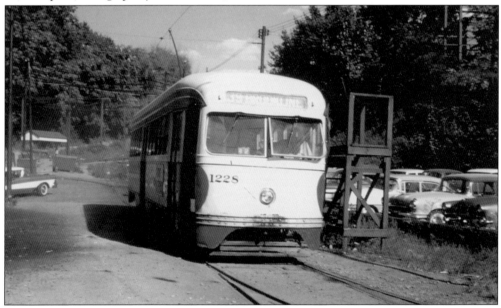

Presidents' Conference Committee car No. 1228 is shown at South Hills Junction on October 26, 1959, ready to go into service on route 39 Brookline. This was an important point on the Pittsburgh Railways Company system, served by nine full-time trolley routes (35–40, 42, 44, and 48) and two rush hour routes (43 and 47). (Photograph by Kenneth C. Springirth.)

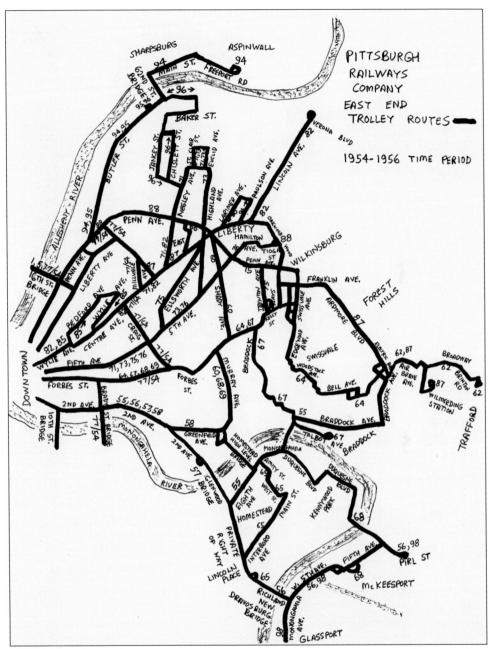

During the 1954–1956 time period, as shown by the map above, the Pittsburgh Railways Company operated 23 trolley routes on the East End of Pittsburgh. Of these routes, 17 entered downtown Pittsburgh (55 Homestead–East Pittsburgh, 56 McKeesport via Second Avenue, 57 Glenwood, 58 Greenfield, 64 Wilkinsburg–East Pittsburgh, 67 Swissvale-Rankin-Braddock, 68 Homestead-Duquesne-McKeesport, 69 Squirrel Hill, 71 Negley, 73 Highland, 75 East Liberty–Wilkinsburg, 76 Hamilton, 82 Lincoln, 85 Bedford, 87 Ardmore, 88 Frankstown, and 94 Sharpsburg-Aspinwall). The remaining six of these routes did not go downtown (60 East Liberty–Homestead, 62 East Pittsburgh–Trafford, 65 Lincoln Place, 77/54 North Side–Carrick via Bloomfield, 96 East Liberty–Sixty-second Street, and 98 Glassport).

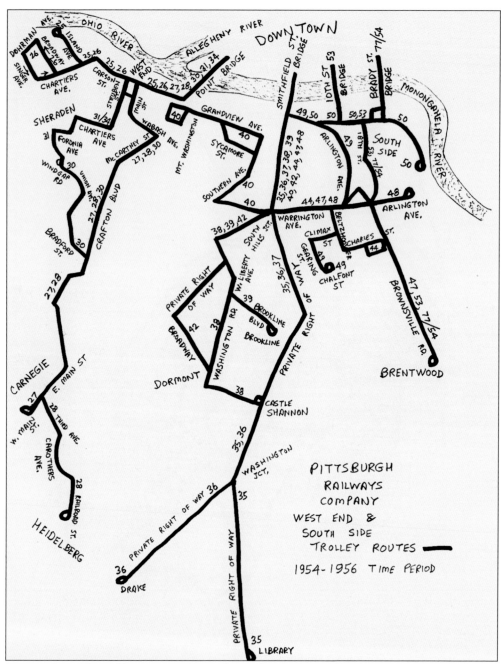

During the 1954–1956 time period, as shown by the map above, the Pittsburgh Railways Company operated six West End trolley routes (25 Island Avenue, 26 West Park, 27 Carnegie, 28 Heidelburg, 30 Crafton-Ingram and 31/34 Elliot-Sheraden-Ingram) and 12 South Side trolley routes (35 Library, 36 Drake, 37 Castle Shannon, 38 Mount Lebanon, 39 Brookline, 40 Mount Washington, 42 Dormont, 44 Knoxville, 48 Arlington, 49 Beltzhoover, 50 Carson Street, and 53 Carrick). There were two South Side rush hour routes (43 Neeld Avenue and 47 Carrick via Tunnel).

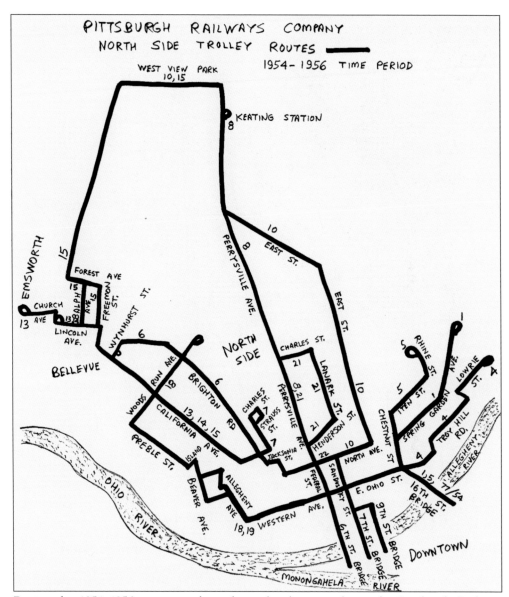

During the 1954–1956 time period, as shown by the map above, the Pittsburgh Railways Company operated 14 North Side trolley routes (1 Spring Garden, 4 Troy Hill, 5 Spring Hill, 6 Brighton Road, 7 Charles Street, 8 Perrysville Avenue, 10 West View, 13 Emsworth, 14 Avalon, 15 Bellevue, 18 Woods Run, 19 Western Avenue, 21 Fineview, and 22 Crosstown). Route 11 East Street operated only during rush hours.

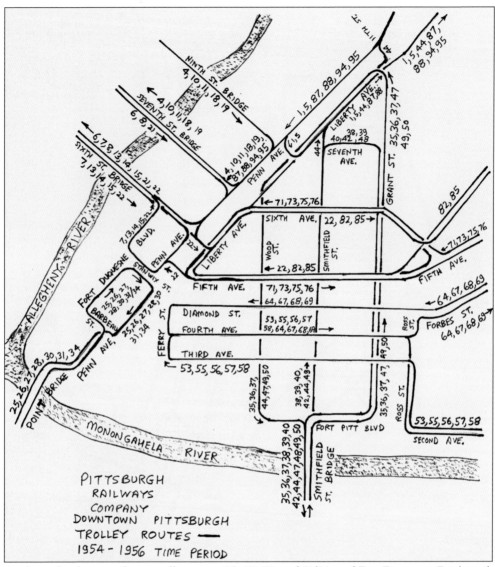

As shown by the map above, trolley routes 25–28, 30, and 31/34 used Fort Duquesne Boulevard, Stanwix Street, and Penn Avenue. Routes 35–37, 47, 49, and 50 used Grant Street, Liberty Avenue, and Wood Street. Route 44 used Smithfield Street, Liberty Avenue, and Wood Street. Routes 38–40, 42, and 48 used Smithfield Street, Seventh Avenue, and Grant Street. Routes 71, 73, 75, and 76 used Sixth Avenue, Liberty Avenue, and Fifth Avenue. Routes 64 and 67–69 used Diamond Street, Ferry Street, and Fourth Avenue. Routes 53 and 55–58 used Third Avenue, Ferry Street, and Fourth Avenue. Routes 4, 10, 11, 18, and 19 used the Ninth Street Bridge, Penn Avenue, and the Seventh Street Bridge. Routes 6, 8, and 21 used the Seventh Street Bridge, Penn Avenue, and the Sixth Street Bridge. Routes 7, 13, 14, and 15 used the Sixth Street Bridge, Penn Avenue, and Stanwix Street. Route 22 used Liberty Avenue, Sixth Avenue, and Fifth Avenue. Routes 1, 5, 87, 88, and 94 used Penn Avenue, Ninth Street, and Liberty Avenue.

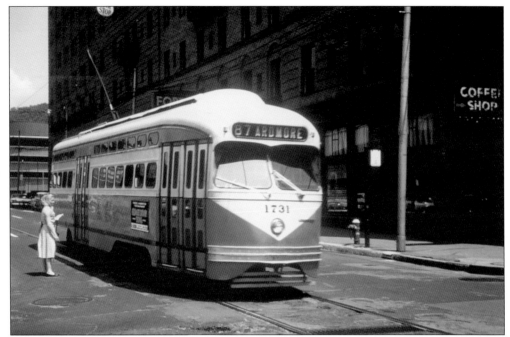

Pittsburgh Railways Company car No. 1731, on route 87 Ardmore, has just come to a stop at Penn Avenue at Tenth Street on June 11, 1961. This Presidents' Conference Committee car, built by the St. Louis Car Company in 1947, had sealed windows that could not be raised or lowered. Each window had a standee window above it, allowing standing passengers to see the surroundings without stooping. (Photograph by Kenneth C. Springirth.)

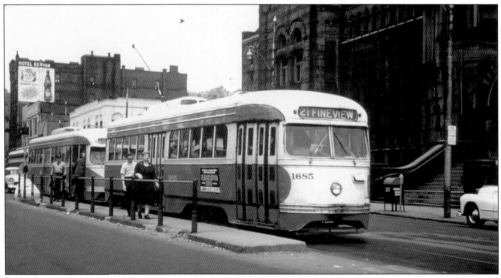

Federal and East Ohio Streets on the North Side of Pittsburgh find Pittsburgh Railways car No. 1685 on route 21 Fineview on June 11, 1961. This route operated from downtown Pittsburgh via the Sixth Street Bridge, Federal Street, Alpine Street, Henderson Street, Lanark Street, Glenrose Street, Charles Street, and Perrysville Avenue. When going inbound to downtown, it traveled via Perrysville Avenue, Federal Street, and the Seventh Street Bridge. (Photograph by Kenneth C. Springirth.)

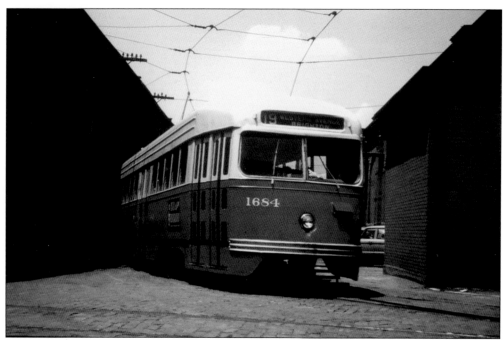

Presidents' Conference Committee car No. 1684 made a brief stop at Manchester Car House on June 11, 1961. Cars Nos. 1600–1699 were built by the St. Louis Car Company in 1946, each costing $20,000. Of these cars, 11 had been modified to handle interurban trolley service on the Washington and Charleroi lines. (Photograph by Kenneth C. Springirth.)

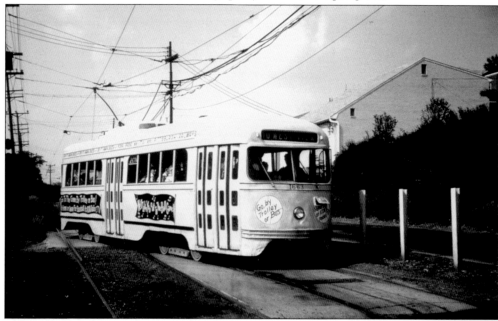

Pittsburgh Railways Company car No. 1663 in a yellow advertising paint scheme is working on route 10 West View at Westfield Avenue on June 11, 1961. Route 10 operated from downtown Pittsburgh using the Seventh Street Bridge, Sandusky Street, North Avenue, East Street, and Perrysville Avenue and had some private right-of-way. (Photograph by Kenneth C. Springirth.)

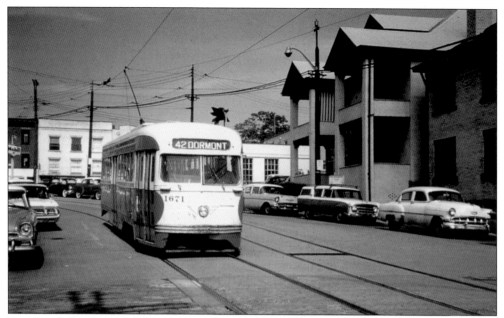

Presidents' Conference Committee car No. 1671 is on Pittsburgh Railways Company route 42 Dormont on Broadway Avenue and Fallowfield Avenue in the Beechview section of Pittsburgh on June 11, 1961. Route 42 operated from downtown Pittsburgh using the Mount Washington Trolley Tunnel to West Liberty Avenue and McFarland Road in Dormont. (Photograph by Kenneth C. Springirth.)

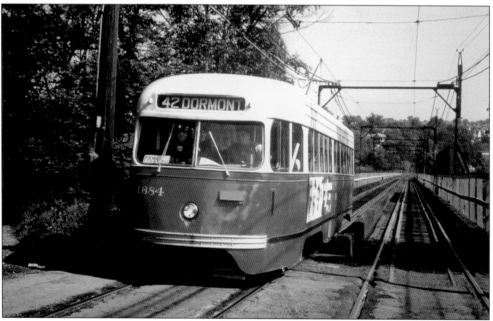

Repainted Presidents' Conference Committee car No. 1684 is posing at a picture stop on a chartered rail excursion on route 42 on June 11, 1961. Rail enthusiasts from all parts of the United States came to Pittsburgh to ride and photograph the extensive and fascinating Pittsburgh Railways Company trolley system. (Photograph by Kenneth C. Springirth.)

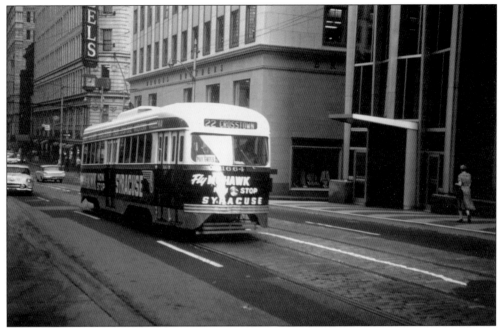

Downtown Pittsburgh provided the setting for Presidents' Conference Committee car No. 1664 on route 22 Crosstown, advertising Mohawk Airlines in a black, white, and gold paint scheme, on September 11, 1961. Route 22 connected downtown Pittsburgh with the North Side business district using Sandusky Street, Ohio Street, Federal Street, and the Sixth Street Bridge. (Photograph by Kenneth C. Springirth.)

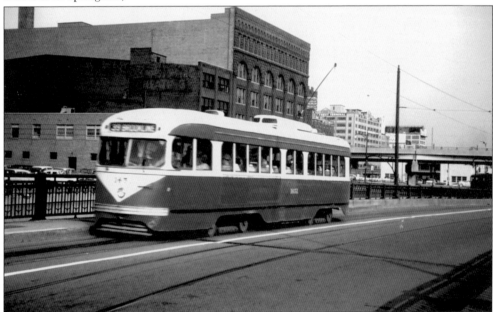

Presidents' Conference Committee car No. 1451 is gliding along Fort Pitt Boulevard, ready to turn south onto the Smithfield Street Bridge on route 39 Brookline, on September 11, 1961. Cars Nos. 1400–1499, built during 1942, featured a wraparound front bumper, and the side passenger windows could be opened and closed. (Photograph by Kenneth C. Springirth.)

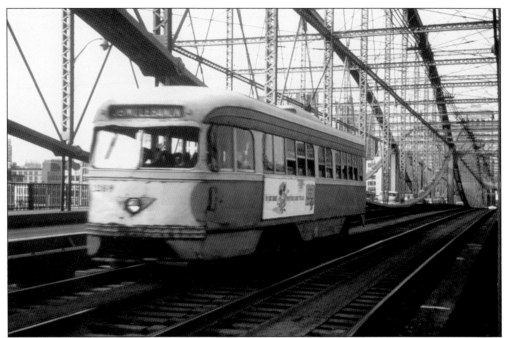

Presidents' Conference Committee car No. 1268, on September 11, 1961, is speeding northward over the Smithfield Street Bridge, heading into downtown Pittsburgh on route 38 Mount Lebanon. Cars Nos. 1200–1299 were built during 1940. Trolley routes 35–40, 42, 43, and 47–50 used this bridge. (Photograph by Kenneth C. Springirth.)

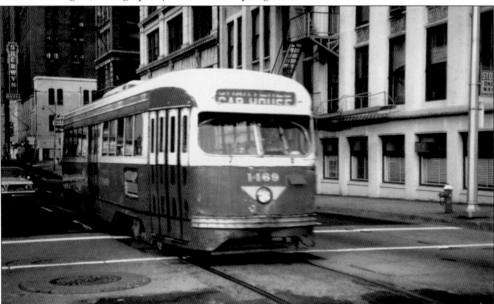

Pittsburgh Railways Company car No. 1469 is southbound on Wood Street, ready to make the turn at Fort Pitt Boulevard on September 11, 1961, heading to Tunnel Car House. Even with the severe decline in ridership, Pittsburgh Railways Company still had a large number of trolleys in service. Routes 35–37, 44, 47, 49, and 50 used this downtown Pittsburgh trackage. (Photograph by Kenneth C. Springirth.)

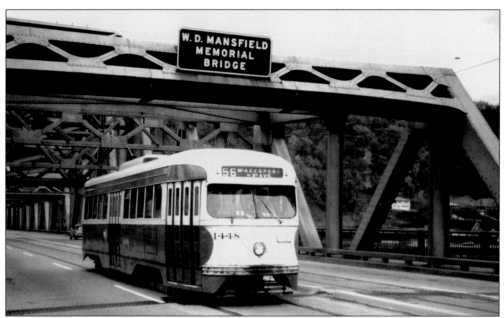

Thundering across the W. D. Mansfield Memorial Bridge is Presidents' Conference Committee car No. 1448, on Pittsburgh Railways Company route 56 McKeesport, on October 21, 1962. This bridge over the Monongahela River linked the borough of Dravosburg with the borough of Glassport. Route 56 operated from downtown Pittsburgh using Second Avenue, Mifflin Road, private right-of-way to Dravosburg, and Fifth Avenue to the city of McKeesport. (Photograph by Kenneth C. Springirth.)

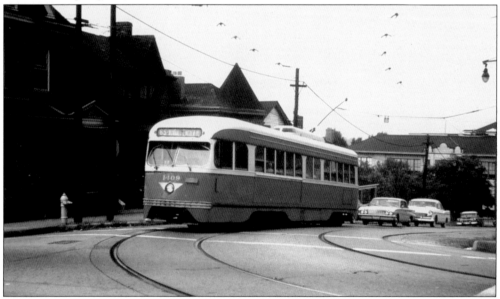

Presidents' Conference Committee car No. 1409, southbound on route 65 Lincoln Place, is on East Twelfth Street, ready to turn onto West Street in the borough of West Homestead on September 11, 1961. Route 65 did not go into downtown Pittsburgh but provided local service along Muldowney Avenue, Interboro Avenue, Main Street, West Street, Twelfth Street, Amity Street, Eighth Avenue, and Munhall Loop. (Photograph by Kenneth C. Springirth.)

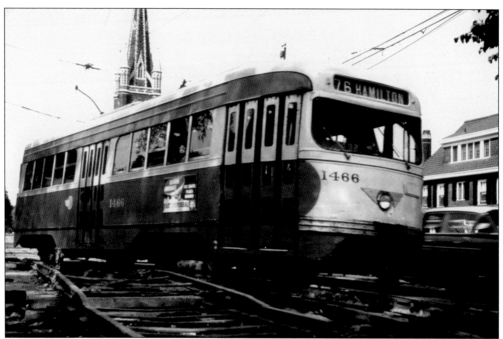

On August 25, 1962, Pittsburgh Railways Company had a major track project going on Fifth Avenue at Maryland Avenue, as Presidents' Conference Committee car No. 1466 on route 76 Hamilton is going over a temporary switch to get over to the other track. This section of Fifth Avenue was also used by route 73 Highland trolleys. (Photograph by Kenneth C. Springirth.)

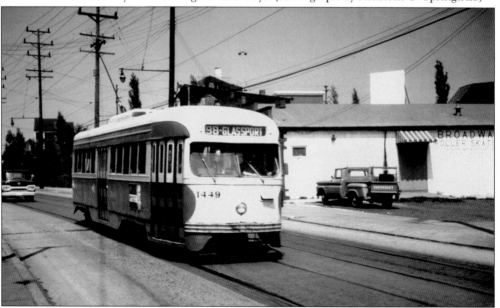

Presidents' Conference Committee car No. 1449 is on Monongahela Avenue in the borough of Glassport on route 98 Glassport on August 25, 1962. The Pittsburgh Railways Company route 98 schedule from April 30, 1961, shows 30-minute service on weekdays. Saturday service was every 30 minutes during midday, with 60-minute service in the early morning and evening. Sunday service was every 60 minutes. (Photograph by Kenneth C. Springirth.)

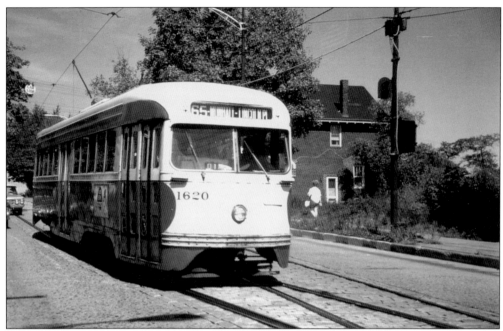

Presidents' Conference Committee car No. 1620 negotiates the passing siding on Pittsburgh Railways Company route 65 at Main Street and Eugene Avenue on September 15, 1962. The route 65 schedule of June 25, 1962, shows weekday service every 20 minutes during the morning and evening rush hours and every 30 minutes during the midday. Saturday service was every 30 minutes. Sunday service was every 60 minutes. (Photograph by Kenneth C. Springirth.)

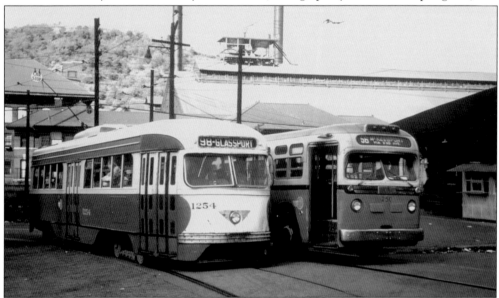

Presidents' Conference Committee car No. 1254 poses at Wilmerding Loop on September 15, 1962, on a chartered trolley excursion. This was the loop for trolley route 87 Ardmore. The 1925 map of interurban lines of Pittsburgh Railways Company shows trolley route 98 operating from the borough of Wilmerding to the borough of Glassport with service every 15 minutes. The bus was actually the route 202 Wilmerding-McKeesport feeder bus. (Photograph by Kenneth C. Springirth.)

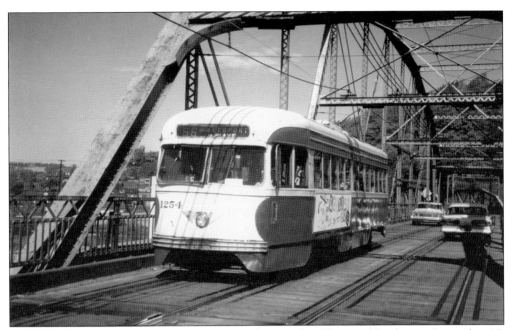

Presidents' Conference Committee car No. 1254 is on the Glenwood Bridge on September 15, 1962. The September 1, 1963, Pittsburgh Railways Company schedule shows route 56 weekday morning rush hour service was every 18 minutes, afternoon rush hour service was every 12–19 minutes, and midday service was every 24 minutes. Saturday service was every 30 minutes. Sunday service was every 40 minutes. (Photograph by Kenneth C. Springirth.)

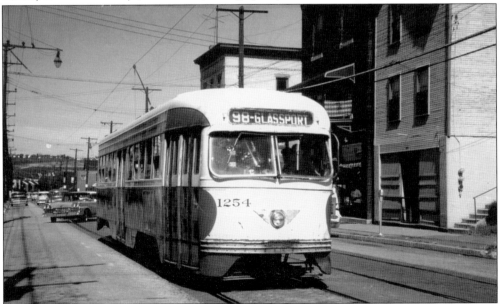

Route 98 Glassport is the setting for Presidents' Conference Committee car No. 1254 on Monongahela Avenue at Fifth Street in the downtown area of the borough of Glassport on a chartered trolley excursion, on September 15, 1962. This line connected the borough of Glassport with city of McKeesport, where trolley route 56 and bus route 68 provided service to downtown Pittsburgh. (Photograph by Kenneth C. Springirth.)

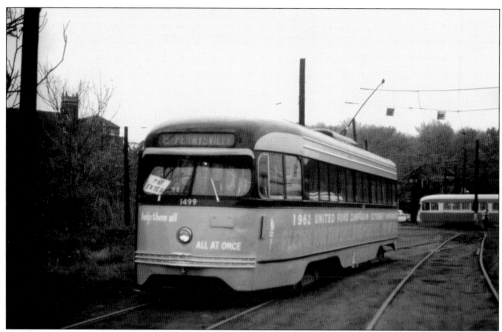

Presidents' Conference Committee car No. 1449, on October 21, 1962, is waiting for the next assignment at Keating Car House, which served the North Side trolley lines of Pittsburgh Railways Company. This car was painted for the 1962 United Fund and featured green sides, black roof, black window area, and white and yellow lettering. (Photograph by Kenneth C. Springirth.)

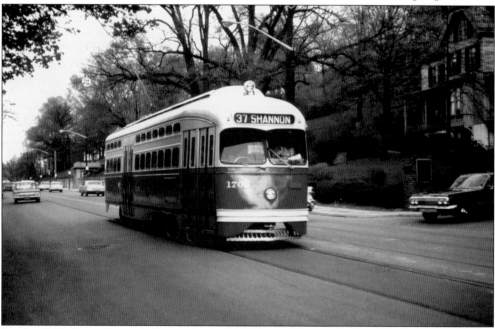

Pittsburgh Railways Company has just repainted Presidents' Conference Committee car No. 1705 with the upper half in cream, the lower half in red, and the cowcatcher in silver. The car is on Fifth Avenue in the East End of Pittsburgh on April 21, 1963. This car was stationed out of Tunnel Car House and served South Side trolley routes. (Photograph by Kenneth C. Springirth.)

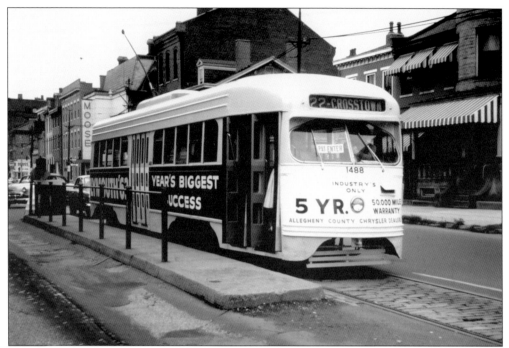

Presidents' Conference Committee car No. 1488 has just picked up a passenger on North Avenue at Sandusky Street on August 3, 1963, in the North Side of Pittsburgh. The painted advertising car not only provided revenue to Pittsburgh Railways Company but also enhanced the appearance of the trolley. (Photograph by Kenneth C. Springirth.)

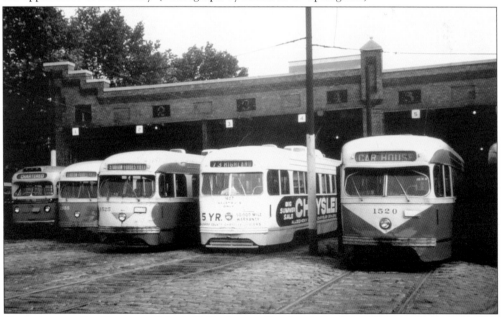

Craft Avenue Car House, on July 4, 1963, shows a Pittsburgh Railways Company bus on the left having a red bottom, light red-orange-tinted window section, and silver roof. Car No. 1555 featured a simplified cream and red paint scheme. Car No. 1525 had a cream front. Car No. 1607 was in light green. Car No. 1520 had a V front in cream and red. (Photograph by Kenneth C. Springirth.)

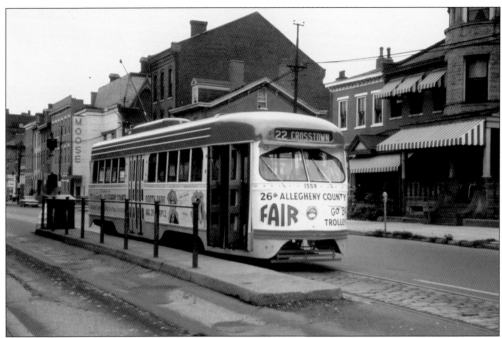

Presidents' Conference Committee car No. 1559, advertising the 26th Allegheny County Fair, had a red roof, white sides, red bumper, green fender, and a yellow lower section. This car is at North Avenue at Sandusky Street on August 3, 1963. Pittsburgh Railways Company provided trolley and bus service to the fair, which generated ridership. (Photograph by Kenneth C. Springirth.)

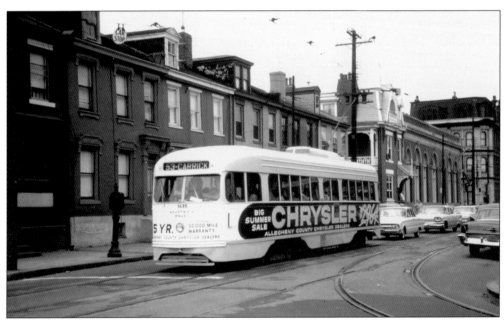

Presidents' Conference Committee car No. 1635 in a light green, white, and blue paint scheme is advertising automobiles on a route 53 Carrick run on August 3, 1963. Route 53 was an appropriate line for the advertisement car, because it connected downtown Pittsburgh with the populous South Side residential area. (Photograph by Kenneth C. Springirth.)

Presidents' Conference Committee car No. 1535 is on Braddock Avenue with the U.S. Route 30 bridge in the background on August 4, 1963. Pittsburgh Railways Company trolley route 55 connected downtown Pittsburgh with the borough of Homestead and the borough of East Pittsburgh, via Second Avenue, Eighth Avenue, Duquesne Boulevard, Braddock Avenue, and North Braddock Avenue. (Photograph by Kenneth C. Springirth.)

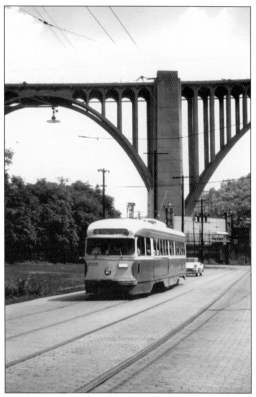

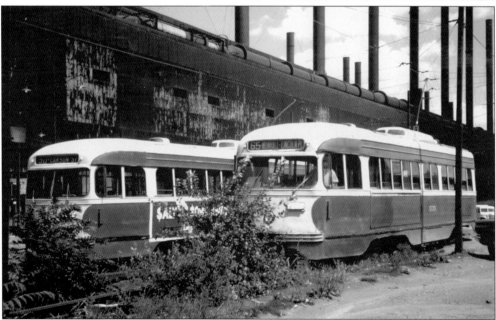

Presidents' Conference Committee cars Nos. 1625 and 1535 are on route 50 at the Thirtieth and Carson Street Loop on August 4, 1963, with the large Jones and Laughlin steel mill in the background. Pittsburgh Railways Company route 50 operated from downtown Pittsburgh via the Smithfield Street Bridge and Carson Street to Thirtieth Street. (Photograph by Kenneth C. Springirth.)

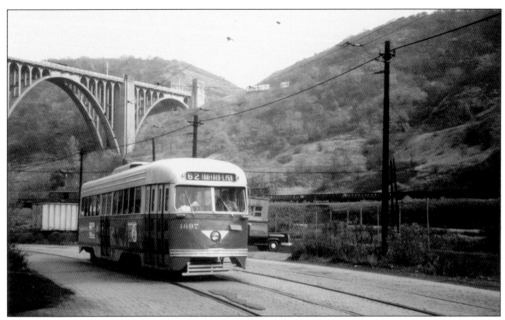

Repainted Presidents' Conference Committee car No. 1697 is on Braddock Avenue with the U.S. Route 30 highway bridge in the background on October 20, 1963. The car is on a rail excursion and is actually on route 55, rather than route 62 shown on the destination sign. Pittsburgh Railways Company had used this attractive, simplified paint scheme on a number of trolleys. (Photograph by Kenneth C. Springirth.)

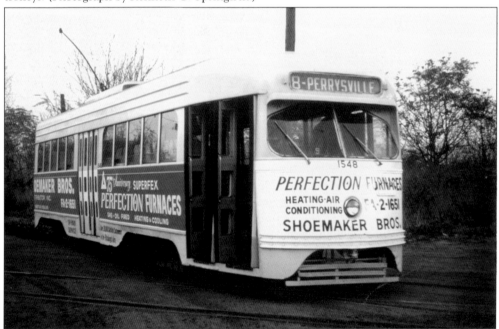

Keating Car House on Perry Avenue, just north of Pittsburgh on October 20, 1963, finds Presidents' Conference Committee car No. 1548 in a light green advertising paint scheme that includes red and white sections with yellow, white, and blue lettering. St. Louis Car Company built cars Nos. 1500–1564 during 1944 and 1945. (Photograph by Kenneth C. Springirth.)

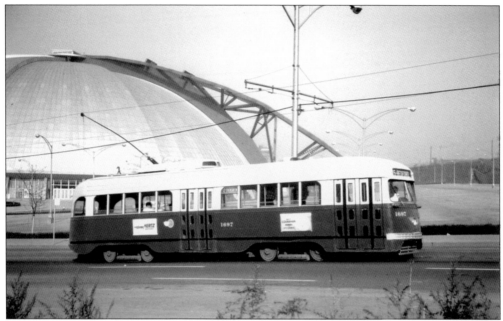

Presidents' Conference Committee car No. 1697 is on Centre Avenue at the dome-shaped Civic Arena on October 20, 1963. Pittsburgh Railways Company trolley routes 82 Lincoln (downtown Pittsburgh via Negley Avenue, Penn Avenue, Frankstown Avenue, and Lincoln Avenue to East Liberty Avenue) and 85 Bedford (downtown Pittsburgh to looping through the Herron Hill section of Pittsburgh) used this trackage. (Photograph by Kenneth C. Springirth.)

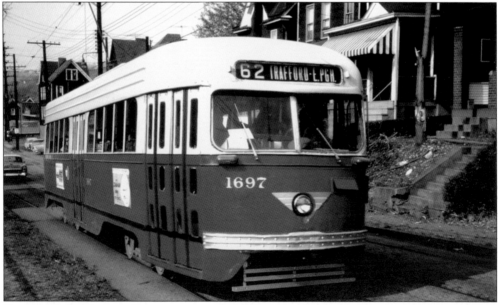

Presidents' Conference Committee car No. 1697 is on Air Brake Avenue in the borough of Turtle Creek east of Pittsburgh, on a rail excursion on October 20, 1963. Pittsburgh Railways Company route 62 (down to one morning franchise run that was abandoned on May 2, 1962) and route 87 (downtown Pittsburgh to the borough of Wilmerding) used this trackage. (Photograph by Kenneth C. Springirth.)

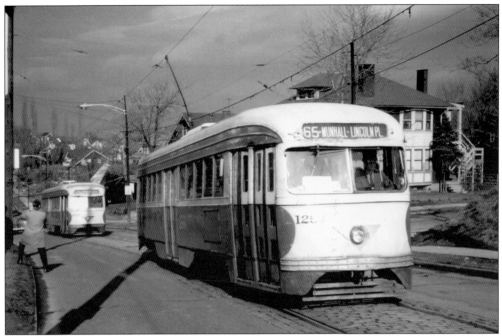

Presidents' Conference Committee cars Nos. 1259 and 1257 are on Main Street at Oliver Road on a chartered rail excursion on February 9, 1964. Pittsburgh Railways Company trolley route 65 featured single track with passing sidings, making it a typical small-town trolley line that attracted students of transportation from all over the country. (Photograph by Kenneth C. Springirth.)

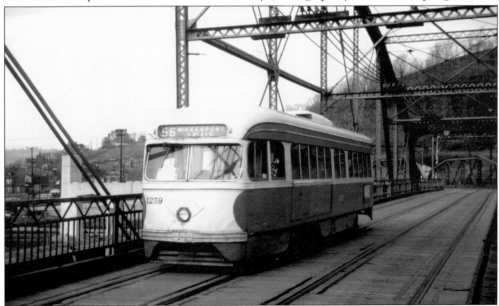

Vintage wood-planked Glenwood Bridge over the Monongahela River finds Presidents' Conference Committee car No. 1259 posing for a picture on a chartered trolley excursion on the Pittsburgh Railways Company system on February 9, 1964. Trolley route 55 (connecting Monongahela River valley towns) and route 56 (linking Pittsburgh with the city of McKeesport) used this trackage. (Photograph by Kenneth C. Springirth.)

Three

PORT AUTHORITY TRANSIT TAKES OVER

On March 1, 1964, the Port Authority of Allegheny County (known as Port Authority Transit) took over Pittsburgh Railways Company and 30 independent bus companies and began converting trolley lines to bus operation. Trolley No. 1673 made the last trip on route 65 Munhall–Lincoln Place leaving Muldowney Loop in the Lincoln Place section of Pittsburgh at 12:33 a.m. on September 5, 1965. Trolley car No. 1438 made the last trip on route 77/54 North Side Carrick via Bloomfield leaving Robinson Street and Sandusky Street on the North Side at 2:00 a.m. on September 5, 1965. Trolley car No. 1777 made the last trip on route 15 Bellevue leaving downtown Pittsburgh at 12:07 a.m. on September 5, 1965. Trolley car No. 1790 made the last trip on route 10 West View leaving downtown Pittsburgh at 12:52 a.m. on September 5, 1965. Trolley car No. 1683 made the last trip on route 8 Perrysville leaving downtown Pittsburgh at 5:05 a.m. on September 5, 1965. Trolley route 21 Fineview made its last run on May 1, 1966. On September 4, 1966, trolley routes 39 Brookline and 40 Mount Washington were replaced by buses, and trolley route 87 Ardmore was cut back from the borough of Wilmerding to the borough of Wilkinsburg. The East End trolley lines were converted to bus operation on January 28, 1967. Trolley car No. 1755 made the last trip on route 64. Trolley car No. 1666 made the last trip on route 67. Trolley car No. 1728 made the last trip on route 71. Trolley car No. 1643 made the last trip on route 73. Trolley car No. 1763 made the last trip on route 75. Trolley car No. 1761 made the last trip on route 76. Trolley car No. 1763 made the last trip on route 82. Trolley car No. 1426 made the last trip on route 87. Trolley car No. 1734 made the last trip on route 88. On November 14, 1971, trolley routes 44 Knoxville, 49 Beltzhoover, and 53 Carrick were converted to bus operation. Four South Hills trolley lines survived: route 35 Shannon Library, route 36 Shannon Drake, route 42/38 Mount Lebanon, and route 49 Arlington-Warrington. A Skybus system had been proposed, but a March 4, 1976, engineering study recommended upgrading the South Hills trolley lines into light-rail transit.

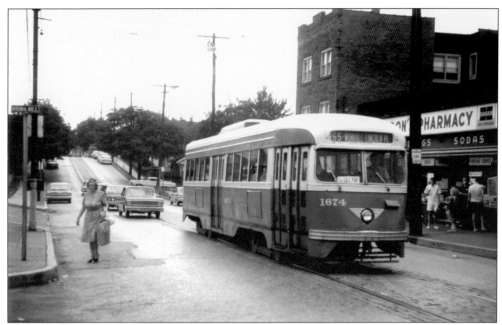

Main Street at Virginia Avenue on July 24, 1964, finds Port Authority Transit route 65 Presidents' Conference Committee car No. 1674 making a passenger stop. Trolley routes 55, 57, and 58 were converted to bus operation on July 5, 1964. Route 65 was extended over route 55 trackage from Munhall Loop to the borough of East Pittsburgh from 5 a.m. to 8 p.m., Monday through Friday. (Photograph by Kenneth C. Springirth.)

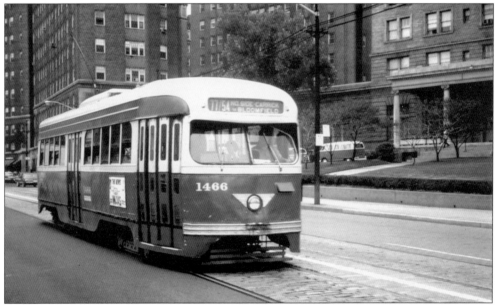

Gliding along Forbes Avenue at Bigelow Boulevard is route 77/54 Presidents' Conference Committee car No. 1466 on July 24, 1964. Port Authority Transit was cutting back on trolley service. Route 22 Crosstown was discontinued on July 5, 1964, and replaced by an extension of bus route 16D. On June 22, 1962, the Castle Shannon Incline on the South Side was abandoned. (Photograph by Kenneth C. Springirth.)

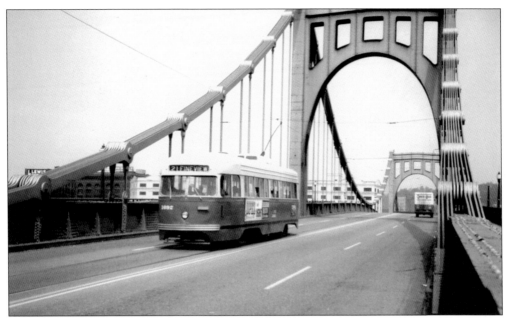

As evidenced by Presidents' Conference Committee car No. 1692 crossing the Ninth Street Bridge over the Allegheny River, heading into downtown Pittsburgh on July 23, 1964, Pittsburgh had an amazing network of trolley lines that included bridges of all types, miles of city street operation, and a large fleet of trolley cars that made the area a special place for rail enthusiasts. (Photograph by Kenneth C. Springirth.)

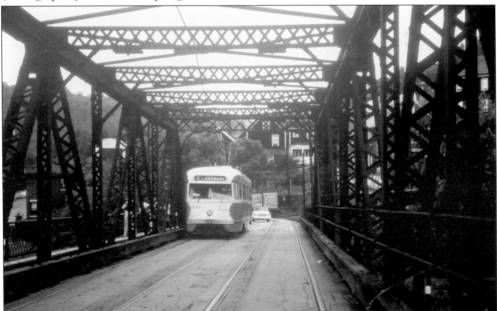

Port Authority Transit route 87 Presidents' Conference Committee car No. 1502 is clanging over the bridge over the Pennsylvania Railroad in the borough of Wilmerding on August 23, 1964. Route 87 Ardmore featured track in the street from downtown Pittsburgh along with center of the road private right-of-way along Ardmore Boulevard in the borough of Forest Hills. It also served the borough of East Pittsburgh. (Photograph by Kenneth C. Springirth.)

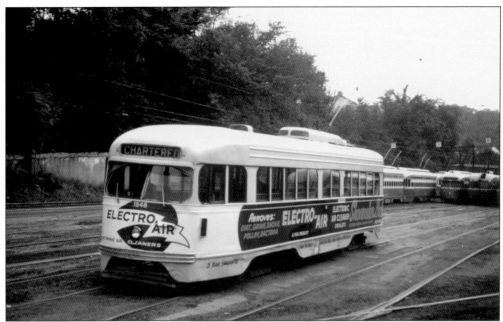

In an attractive advertising paint scheme, Presidents' Conference Committee car no. 1548 is parked at Tunnel Car House on July 24, 1964. Port Authority Transit had taken over three car houses from Pittsburgh Railways Company. Tunnel Car House was the largest and served South Side trolley routes. Keating Car House served North Side trolley routes. Craft Avenue Car House served East End trolley routes. (Photograph by Kenneth C. Springirth.)

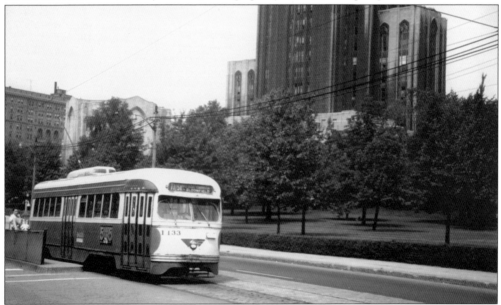

Forbes Avenue at the University of Pittsburgh provides the setting for Presidents' Conference Committee car No. 1433 on Port Authority Transit route 77/54 on July 24, 1964. This route connected the North Side with Oakland and also served the South Side of Pittsburgh. The line used the Sixteenth Street Bridge over the Allegheny River and the Twenty-second Street Bridge over the Monongahela River. (Photograph by Kenneth C. Springirth.)

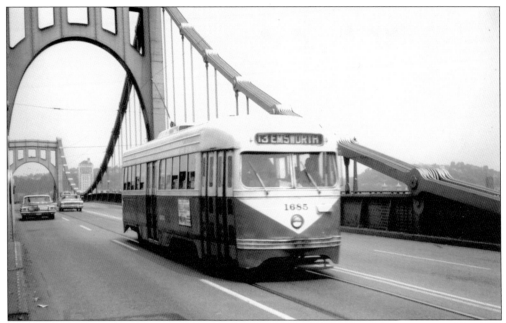

Port Authority Transit route 13 Emsworth has Presidents' Conference Committee car No. 1685 on the Ninth Street Bridge, heading into downtown Pittsburgh on July 25, 1964. Route 13 served the boroughs of Bellevue, Avalon, Ben Avon, and Emsworth on a bluff overlooking the north side of the Ohio River. (Photograph by Kenneth C. Springirth.)

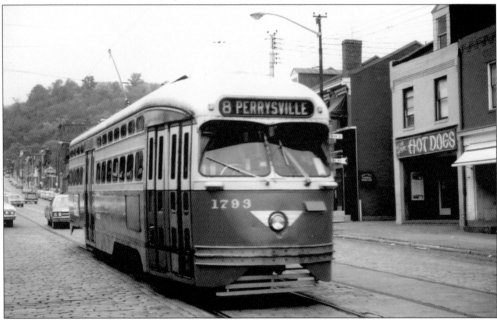

Federal Street at North Avenue finds Presidents' Conference Committee car No. 1793 on Port Authority Transit route 8 Perrysville on May 23, 1965. Route 8 was a busy North Side trolley line operating from Keating Car House (located outside the city along Perry Highway) to downtown Pittsburgh, via a scenic area along winding Perrysville Avenue. (Photograph by Kenneth C. Springirth.)

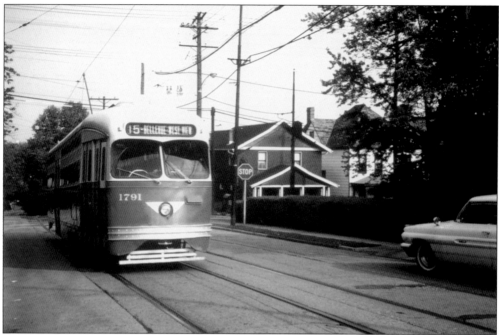

Forest Avenue and Balph Avenue in the borough of Bellevue is the scene for Presidents'
Conference Committee car No. 1791 on May 23, 1965, operating on Port Authority Transit
route 15 Bellevue. This line operated from downtown Pittsburgh to the borough of West View
where the operator would change the destination sign to route 10 for the inbound trip to
downtown Pittsburgh. (Photograph by Kenneth C. Springirth.)

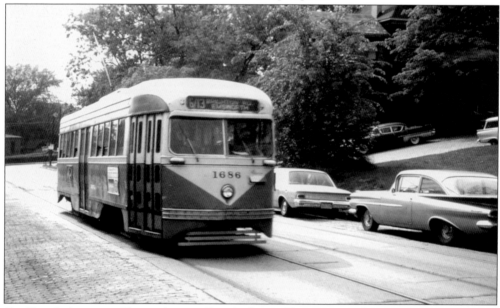

On Church Avenue at Plumer Avenue, Port Authority Transit route 6/13 Presidents' Conference
Committee car No. 1686 is traversing the picturesque borough of Emsworth on May 23, 1965.
During evenings and Sundays, route 6 Brighton Road was combined with route 13 Emsworth
and designated route 6/13 Brighton-Emsworth. (Photograph by Kenneth C. Springirth.)

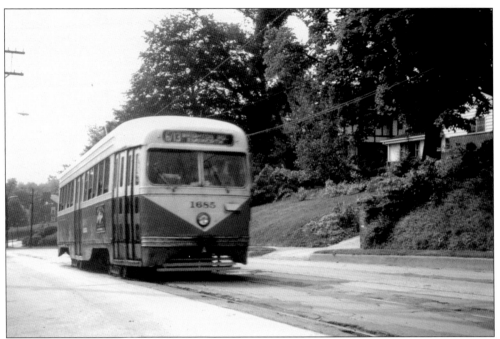

Pittsburgh's North Side featured scenic suburban areas, such as this view of Presidents' Conference Committee car No. 1685 on Church Avenue at Hazelwood Avenue operating on route 6/13, on May 23, 1965. Pittsburgh's track gauge is five feet two and a half inches, which is six inches wider than the standard railroad gauge. (Photograph by Kenneth C. Springirth.)

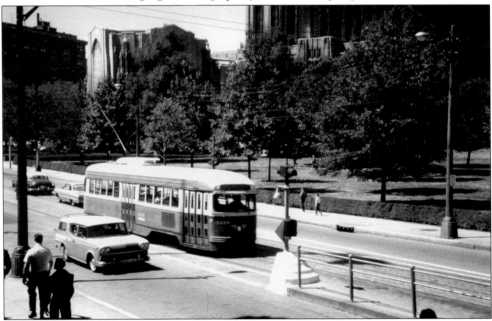

A route 77/54 Presidents' Conference Committee car No. 1438 is traversing Forbes Avenue at Schenley Drive, with the University of Pittsburgh in the background in the Oakland section of Pittsburgh on August 29, 1965. This section of Forbes Avenue was also served by Port Authority Transit trolley routes 64 and 67–69. (Photograph by Kenneth C. Springirth.)

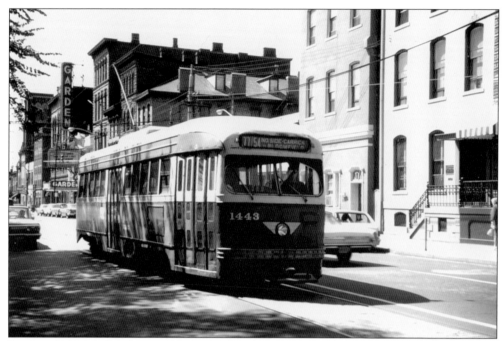

Pittsburgh's North Side business district on North Avenue near Sandusky Street finds Presidents' Conference Committee car No. 1443 on route 77/54 on August 29, 1965. Port Authority Transit converted this line to bus operation on September 5, 1965, along with trolley routes 8, 10, 11, 15, and 65/55. (Photograph by Kenneth C. Springirth.)

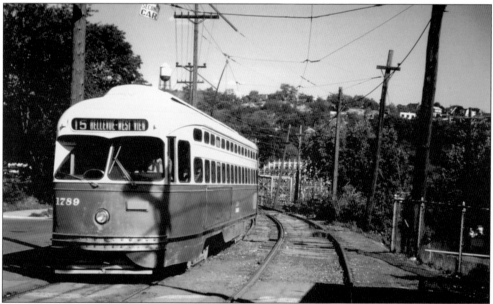

Presidents' Conference Committee car No. 1789 is operating on route 15 Bellevue–West View on August 29, 1965. With the roller coaster in the background, West View Park was the last amusement park in the United States served by a trolley line. Port Authority Transit converted this line to bus operation on September 5, 1965. The last regular service car on this line was car No. 1790. (Photograph by Kenneth C. Springirth.)

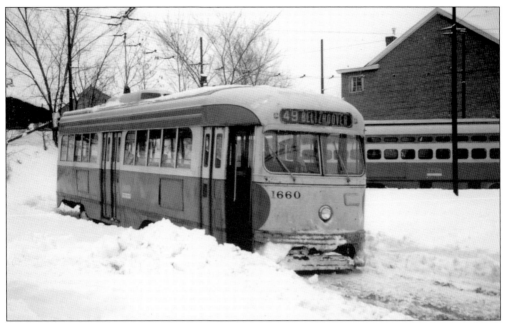

Pittsburgh does receive winter snow, as evidenced by Presidents' Conference Committee cars Nos. 1660 and 1795 at the Port Authority Transit route 49 Beltzhoover Loop on January 23, 1966. This line served as a bypass for the South Hills Tunnel in case of an emergency. Portions of the line represented the classic, small-town, single-track trolley line with a passing siding in the street. (Photograph by Kenneth C. Springirth.)

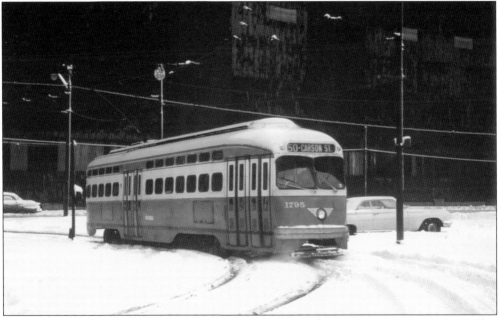

A wintertime rail enthusiast excursion finds Presidents' Conference Committee car No. 1795 in the snow at the Thirtieth and Carson Street Loop of route 50, with the Jones and Laughlin steel mill in the background, on January 23, 1966. Port Authority Transit converted this line to bus operation on February 27, 1966. (Photograph by Kenneth C. Springirth.)

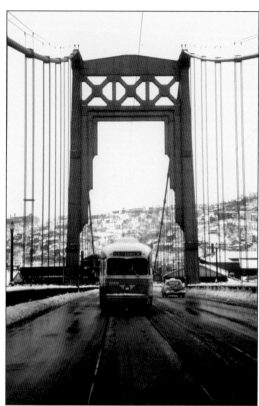

This January 23, 1966, winter snow scene illustrates the efficient snow removal in Pittsburgh on main traffic routes, with Port Authority Transit allowing a rail excursion in spite of a heavy snowfall. Presidents' Conference Committee car No. 1795 has paused for a photograph stop on the Tenth Street Bridge over the Monongahela River on route 53. (Photograph by Kenneth C. Springirth.)

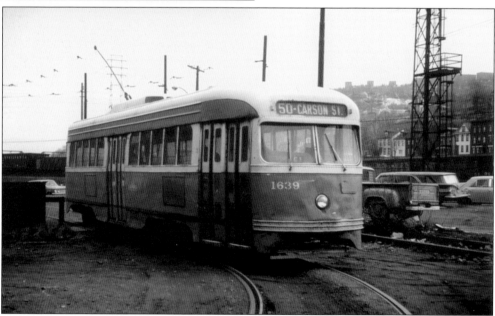

The Thirtieth and Carson Street Loop of route 50 Carson Street is the scene for Presidents' Conference Committee car No. 1639 on February 26, 1966. This was the last day of trolley car operation for this line, which operated on the south side of the Monongahela River. Port Authority Transit began replacement bus service the next day. (Photograph by Kenneth C. Springirth.)

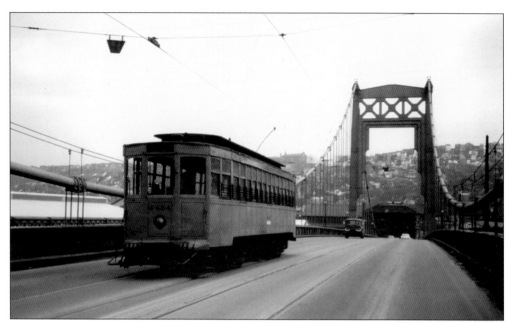

Snow scraper car No. M454 is on the Tenth Street Bridge on February 26, 1966. This originally was car No. 4115, built by Pressed Steel Car Company in 1911 for Pittsburgh Railways Company. It became a snow scraper car during November 1940. Port Authority Transit acquired 25 work cars and 288 Presidents' Conference Committee cars when it took over Pittsburgh Railways Company on March 1, 1964. (Photograph by Kenneth C. Springirth.)

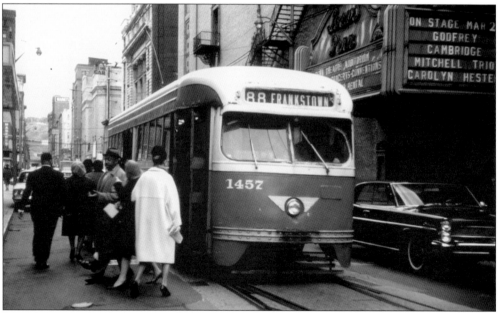

Penn Avenue at Sixth Avenue in downtown Pittsburgh finds Presidents' Conference Committee car No. 1457 making a passenger stop on March 19, 1966, for Port Authority Transit route 88 Frankstown. This line operated from downtown Pittsburgh to the East End, via Penn Avenue to East Liberty and Frankstown Avenues to a full-circle loop at Tioga Street. (Photograph by Kenneth C. Springirth.)

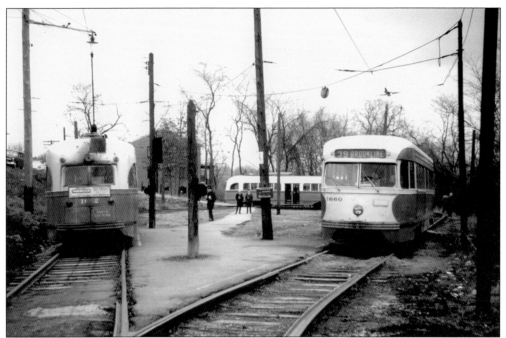

Route 39 Brookline Loop is the scene for Presidents' Conference Committee car No. 1652 (left, back end), car No. 1623 (center, in back of loop), and car No. 1660 (right, facing front) on March 20, 1966. The Port Authority Transit route 39 schedule for November 28, 1965, shows rush hour service every 10 minutes, midday service on weekdays every 20 minutes, and weekend service every 30 minutes. (Photograph by Kenneth C. Springirth.)

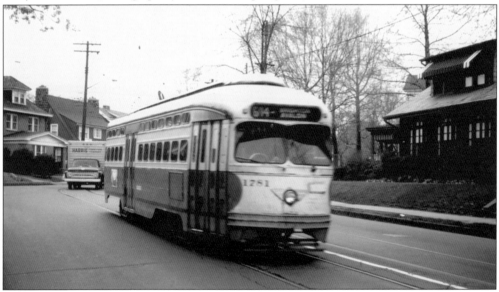

Brighton Road at Pemberton Avenue near Shadeland Avenue finds Presidents' Conference Committee car No. 1781 passing by on route 6/14, on the final day of trolley operation, April 30, 1966. Port Authority Transit converted this line to bus operation the next day. Due to deteriorated bridges, the section of the line between Avalon Loop and Emsworth made its last run on December 31, 1965. (Photograph by Kenneth C. Springirth.)

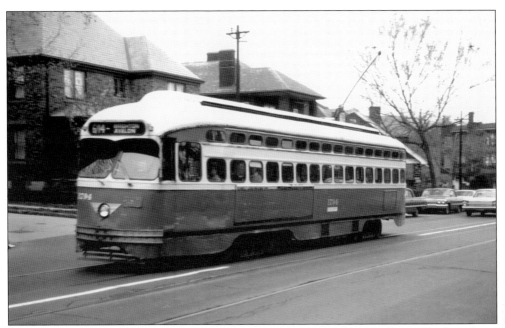

Presidents' Conference Committee car No. 1794 is on route 6/14 Brighton-Avalon on Brighton Road at Pemberton Avenue, on April 30, 1966, the last day of trolley car operation. This was a scenic trolley line that served the suburban area on the north side of the Ohio River. Port Authority Transit converted the line to bus operation on May 1, 1966. (Photograph by Kenneth C. Springirth.)

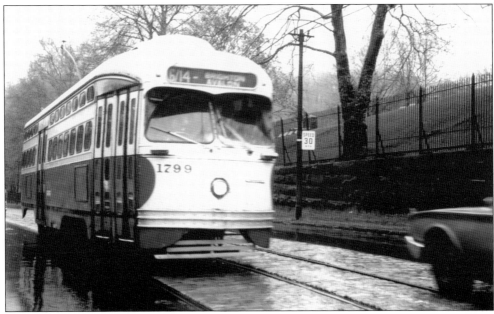

On a rainy April 30, 1966, Presidents' Conference Committee car No. 1799 is swiftly traveling along Brighton Road at Highwood Cemetery on route 6/14, inbound for downtown Pittsburgh on the final day of trolley service for Pittsburgh's North Side. With the closure of routes 6/14 and 21, Port Authority Transit ended trolley service north of the Ohio and Monongahela Rivers. (Photograph by Kenneth C. Springirth.)

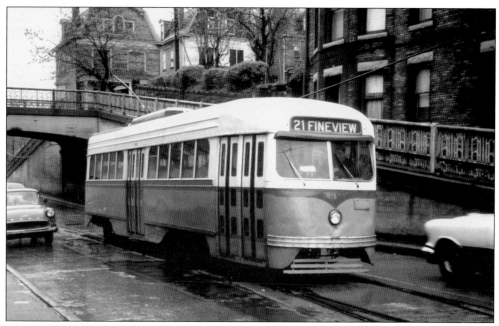

Charles Street near Perrysville Avenue is the setting for Presidents' Conference Committee car No. 1678 on April 30, 1966, the final day of operation for route 21 Fineview. This line featured a 15.5 percent grade, which was one of the steepest straight adhesion grades in the world. Port Authority Transit converted the line to bus operation on May 1, 1966. (Photograph by Kenneth C. Springirth.)

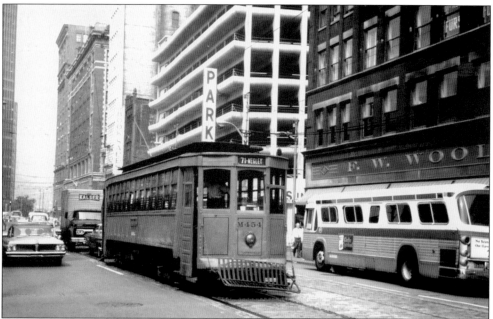

High-floor car No. M454 is on Liberty Avenue near Oliver Avenue in downtown Pittsburgh on June 25, 1966. Trolley routes 71, 73, 75, and 76 used this trackage. The Pennsylvania Railway Museum Association acquired this car from Port Authority Transit on June 24, 1976, and it arrived at the museum the week of July 26, 1976. (Photograph by Kenneth C. Springirth.)

North St. Clair and Bowden Streets on the East End of Pittsburgh set the scene for high-floor car No. M454 and Presidents' Conference Committee car No. 1553 on June 25, 1966. Trolley route 71 reached Highland Park via Negley Avenue. Trolley route 73 reached Highland Park by Highland Avenue. (Photograph by Kenneth C. Springirth.)

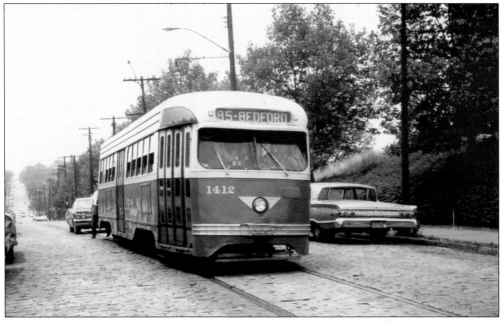

Presidents' Conference Committee car No. 1412 is traversing route 85 Bedford on the last day of trolley car operation for this line, June 25, 1966. This line connected downtown Pittsburgh with the Herron Hill section of Pittsburgh, via Wylie Avenue and Bedford Avenue. Port Authority Transit began operating buses on this line on June 26, 1966. (Photograph by Kenneth C. Springirth.)

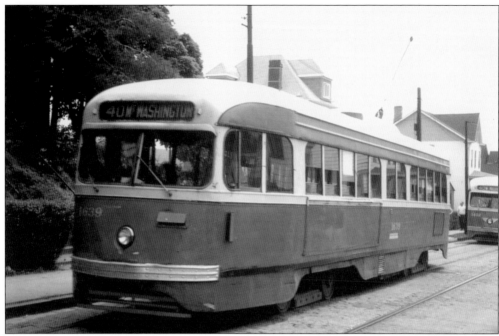

Fingal Street and Rutledge Street, on route 40 Mount Washington, are busy on June 25, 1966. Presidents' Conference Committee cars Nos. 1639 and 1412 are seen awaiting departure time. Route 40 climbed the hill on the south bank of the Monongahela River and ran along Grandview Avenue, which provided a panoramic view of Pittsburgh. This Port Authority Transit line served the Monongahela Incline and Duquesne Incline. (Photograph by Kenneth C. Springirth.)

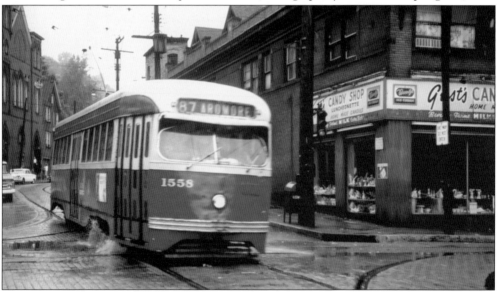

On August 14, 1966, Presidents' Conference Committee car No. 1558 is traveling along rain-soaked Linden Avenue at Beech Street in the borough of East Pittsburgh. Port Authority Transit trolley route 64 Wilkinsburg–East Pittsburgh and route 87 Ardmore intersected in the borough of East Pittsburgh. Both trolley lines provided direct trolley service to downtown Pittsburgh. (Photograph by Kenneth C. Springirth.)

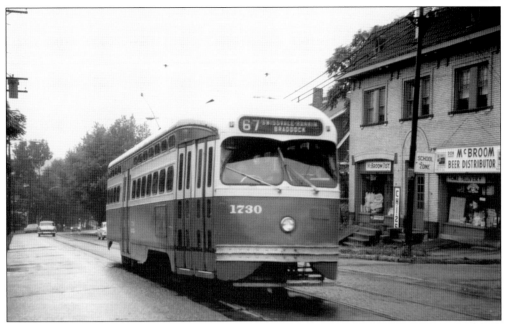

Presidents' Conference Committee car No. 1730 is southbound on route 67 on Braddock Avenue at Sanders Street, which is six blocks south of Forbes Avenue, on August 14, 1966. Port Authority Transit route 67 Swissvale-Rankin-Braddock linked downtown Pittsburgh with the borough of Braddock, via Forbes, Braddock, Monongahela, and Talbot Avenues. (Photograph by Kenneth C. Springirth.)

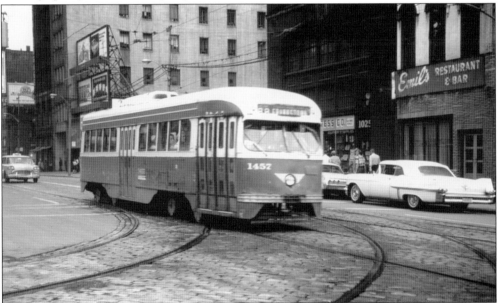

Liberty Avenue and Grant Street finds Presidents' Conference Committee car No. 1457 heading out of downtown Pittsburgh on route 88 on August 14, 1966. Port Authority Transit route 88 Frankstown had a large ridership and operated 24 hours a day, daily. As the first step in the conversion to bus operation, buses were used on Saturdays and Sundays, effective September 4, 1966. (Photograph by Kenneth C. Springirth.)

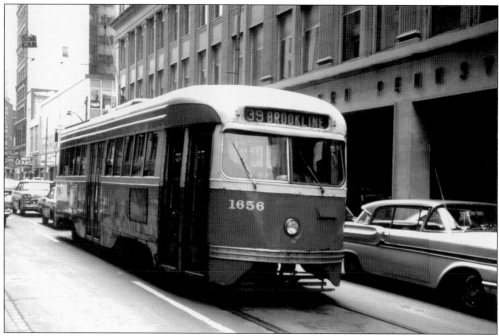

Presidents' Conference Committee car No. 1656 is on route 39 Brookline on Smithfield Street at Fifth Avenue on August 14, 1966. Route 39 connected downtown Pittsburgh with Brookline Boulevard. On September 3, 1966, Port Authority Transit converted trolley routes 39 and 40 to bus operation and cut back route 87 from the borough of Wilmerding to Jane Street Loop in the borough of Wilkinsburg. (Photograph by Kenneth C. Springirth.)

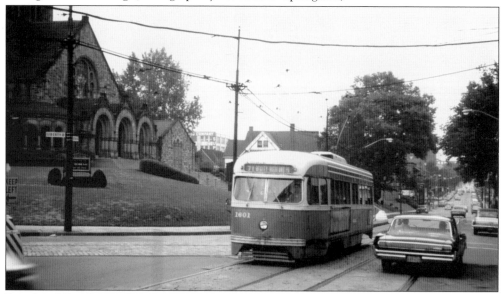

Presidents' Conference Committee car No. 1601 is on Centre Avenue at Liberty Avenue heading for downtown Pittsburgh on route 71 on August 14, 1966. Trackage going to the left on Liberty Avenue was used by route 87 trolleys and, up to September 4, 1965, by route 77/54 trolleys. Port Authority Transit converted route 77/54 to bus operation on September 5, 1965. (Photograph by Kenneth C. Springirth.)

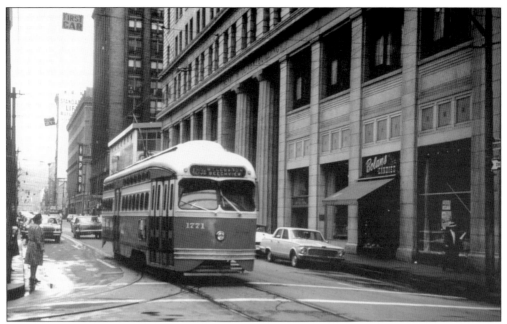

Smithfield Street and Sixth Avenue finds Presidents' Conference Committee car No. 1771 northbound in downtown Pittsburgh on Port Authority Transit route 42/38 Mount Lebanon via Beechview on August 14, 1966. On May 26, 1963, route 38 Mount Lebanon was combined with route 42 Dormont by Pittsburgh Railways Company and became route 42/38. This resulted in the abandonment of West Liberty Avenue trackage between Dormont and Brookline Junction. (Photograph by Kenneth C. Springirth.)

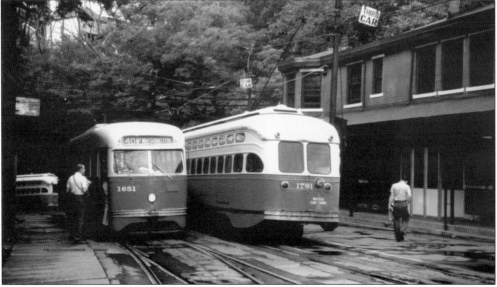

On August 14, 1966, at South Hills Junction, Presidents' Conference Committee car No. 1651 is ready to make the run on route 40 to Mount Washington, as Presidents' Conference Committee car No. 1791 is heading northbound to downtown Pittsburgh via the South Hills Trolley Tunnel. Port Authority Transit converted route 40 to bus operation on September 3, 1966. (Photograph by Kenneth C. Springirth.)

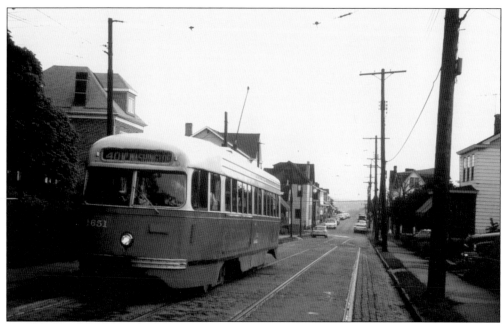

Presidents' Conference Committee car No. 1651 is on Rutledge Street and Fingal Street on route 40 Mount Washington on August 14, 1966. Port Authority Transit converted route 40 to bus operation on September 3, 1966. Route 40, completed on March 26, 1930, was a classic Pittsburgh trolley line that operated through the Mount Washington Trolley Tunnel and featured a 10.5 percent grade and some single trackage. (Photograph by Kenneth C. Springirth.)

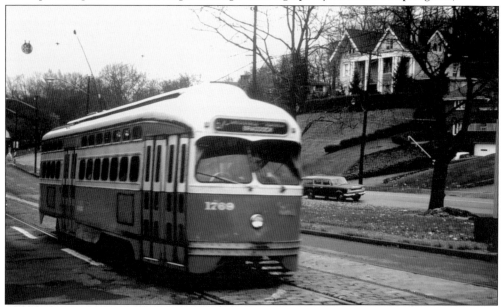

Forbes Avenue near South Dallas Avenue finds Presidents' Conference Committee car No. 1769 on route 67 on November 8, 1966. From downtown Pittsburgh, routes 64 and 67 shared trackage along Forbes Avenue to Braddock Avenue, where route 64 continued east, to the borough of Wilkinsburg and the borough of East Pittsburgh. Route 67 turned south, to the borough of Braddock. (Photograph by Kenneth C. Springirth.)

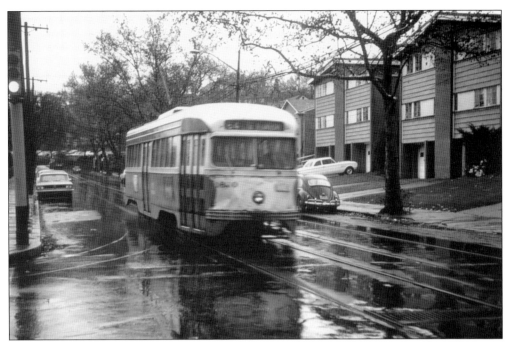

On a rain-swept November 8, 1966, Presidents' Conference Committee car No. 1670 is on Forbes Avenue at Margaret Morrison Street on Port Authority Transit route 64. Trolley service on Pittsburgh's East End, since September 4, 1966, was operated Monday through Friday, and buses were used on Saturday and Sunday. (Photograph by Kenneth C. Springirth.)

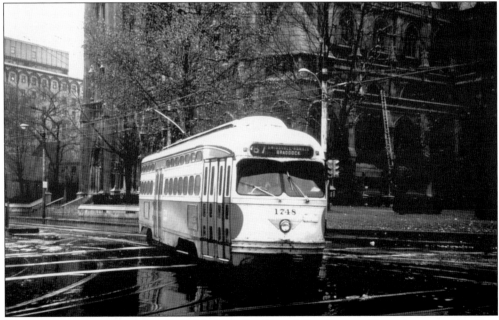

The steady rain of November 8, 1966, finds Presidents' Conference Committee car No. 1748 with its front silver wings on Fifth Avenue and South Craig Street in the majestic Oakland section of Pittsburgh, on route 67. By January 28, 1967, buses had replaced all East End trolleys. (Photograph by Kenneth C. Springirth.)

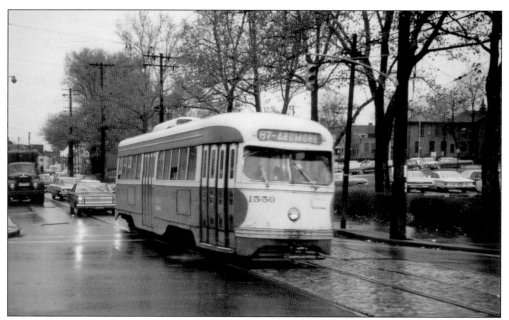

Presidents' Conference Committee car No. 1550 is outbound on Frankstown Avenue and Washington Avenue on route 87 on November 8, 1966. Port Authority Transit had cut route 87 from the borough of Wilmerding to Jane Street Loop in the borough of Wilkinsburg on September 3, 1966. This eliminated the last section of private right-of-way in the East End trolley routes of Pittsburgh. (Photograph by Kenneth C. Springirth.)

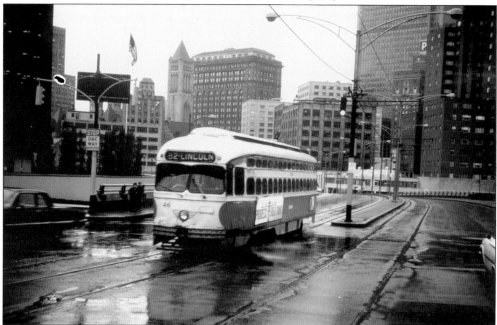

A rainy November 8, 1966, finds Presidents' Conference Committee car No. 1746 on route 82 on Centre Avenue near Washington Place, in downtown Pittsburgh. This was a busy East End trolley route that as of September 4, 1966, operated trolleys Monday through Friday and buses on Saturday and Sunday. (Photograph by Kenneth C. Springirth.)

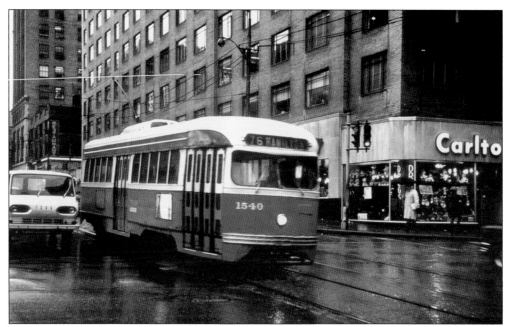

Sixth Avenue and Bigelow Boulevard finds Presidents' Conference Committee car No. 1540 in downtown Pittsburgh, on Port Authority Transit route 76 Hamilton on November 8, 1966. Route 76 connected downtown Pittsburgh with the borough of Wilkinsburg via Fifth Avenue, Hamilton Avenue, Brushton Avenue, Tioga Street, Atwood Street, Penn Avenue, and Swissvale Avenue. (Photograph by Kenneth C. Springirth.)

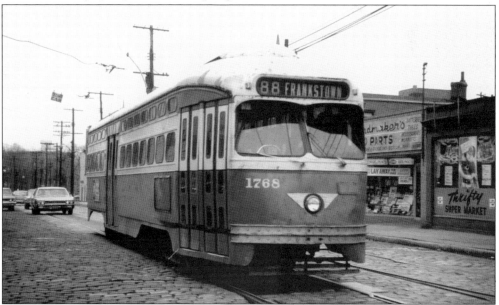

Presidents' Conference Committee car No. 1768 is eastbound on Frankstown Avenue at Lincoln Avenue on route 88 on January 2, 1967. This portion of Frankstown Avenue was used by trolley routes 82, 87, and 88, with route 82 branching onto Lincoln Avenue. In less than one month, on January 28, 1967, Port Authority Transit converted all East End trolley routes to bus operation. (Photograph by Kenneth C. Springirth.)

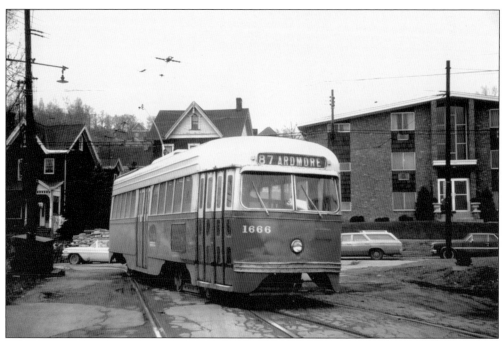

Route 87 Presidents' Conference Committee car No. 1666 is turning into Jane Street Loop in the borough of Wilkinsburg on January 2, 1967. On September 3, 1966, Port Authority Transit cut back route 87 from the borough of Wilmerding to Jane Street Loop. This was one of the 10 East End trolley lines that were converted to bus operation on January 28, 1967. (Photograph by Kenneth C. Springirth.)

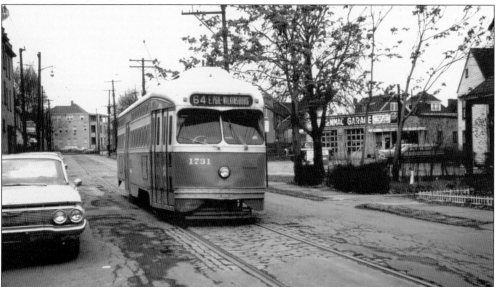

Presidents' Conference Committee car No. 1731 is on Rebecca Avenue and Mill Street on January 2, 1967, outbound to the borough of East Pittsburgh on route 64. Port Authority Transit converted this line to bus operation on January 28, 1967. Route 64 provided the fastest direct trolley car connection between the borough of Wilkinsburg and downtown Pittsburgh. (Photograph by Kenneth C. Springirth.)

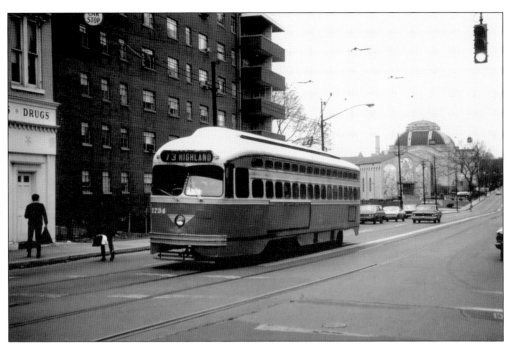

Fifth Avenue at Neville Street finds Presidents' Conference Committee car No. 1734 operating on route 73 Highland on January 2, 1967. Port Authority Transit converted this line to bus operation on January 28, 1967. Route 73 connected downtown Pittsburgh with Highland Park via Fifth Avenue and Highland Avenue. (Photograph by Kenneth C. Springirth.)

Presidents' Conference Committee car No. 1754 is turning from Fifth Avenue to Neville Street on route 75 on January 2, 1967. Port Authority Transit converted this line to bus operation on January 28, 1967. Route 75 connected downtown Pittsburgh with the borough of Wilkinsburg via Fifth Avenue, Neville Street, Ellsworth Avenue, and Penn Avenue. (Photograph by Kenneth C. Springirth.)

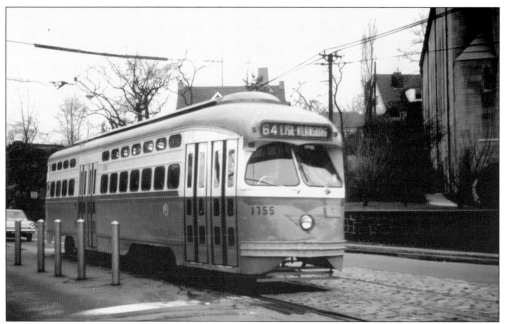

Forbes Avenue at Braddock Avenue finds Presidents' Conference Committee car No. 1755 on Port Authority Transit route 64, outbound to the borough of Wilkinsburg and the borough of East Pittsburgh on January 2, 1967. Routes 64 and 67 shared trackage from downtown Pittsburgh to this point, with route 64 continuing to the borough of East Pittsburgh and route 67 heading south to the borough of Braddock. (Photograph by Kenneth C. Springirth.)

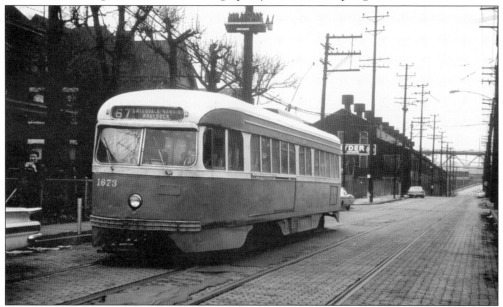

Presidents' Conference Committee car No. 1673, on Talbot Avenue at Grape Street, is outbound to Thirteenth Street and Talbot Avenue in the borough of Braddock on January 2, 1967. Route 67 connected downtown Pittsburgh with the boroughs of Swissvale, Rankin, and Braddock. On January 28, 1967, this line and all remaining East End trolley lines were converted to bus operation. (Photograph by Kenneth C. Springirth.)

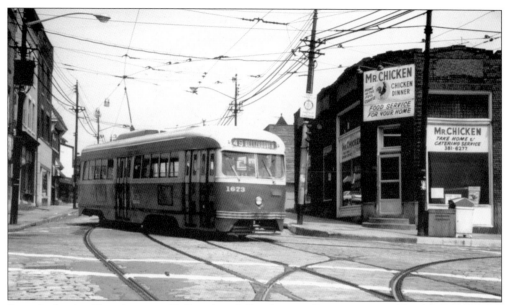

Port Authority Transit route 49 Presidents' Conference Committee car No. 1673 is turning from Warrington Avenue to Beltzhoover Avenue on July 16, 1967, in the Allentown section of Pittsburgh. This line from downtown Pittsburgh wound around Arlington and Warrington Avenues and served as an emergency bypass for the Mount Washington Trolley Tunnel. (Photograph by Kenneth C. Springirth.)

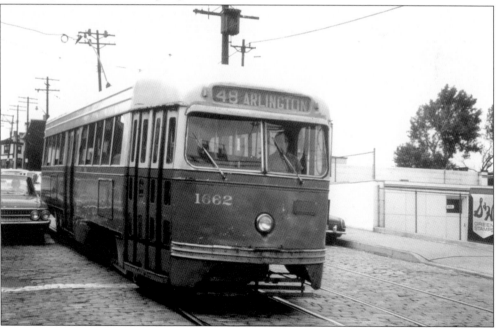

Presidents' Conference Committee car No. 1662 is on Arlington Avenue, serving Port Authority Transit route 48 on July 16, 1967. This line connected downtown Pittsburgh with the Arlington section of Pittsburgh via the Mount Washington Trolley Tunnel, Warrington Avenue, and Arlington Avenue to Eleanor Street. There was not much clearance between the parked automobile and the trolley, as evidenced in this view. (Photograph by Kenneth C. Springirth.)

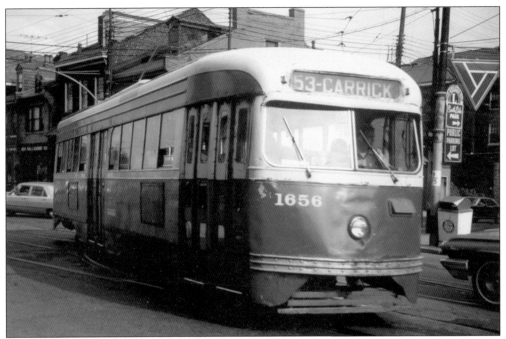

Brownsville Road and Arlington Avenue provide the setting for Presidents' Conference Committee car No. 1656 on Port Authority Transit route 53 on July 16, 1967. Route 53 was a long line connecting downtown Pittsburgh with the boroughs of Mount Oliver and Brentwood via Second Avenue, the Tenth Street Bridge, Carson Street, and Brownsville Road to Brentwood Loop. (Photograph by Kenneth C. Springirth.)

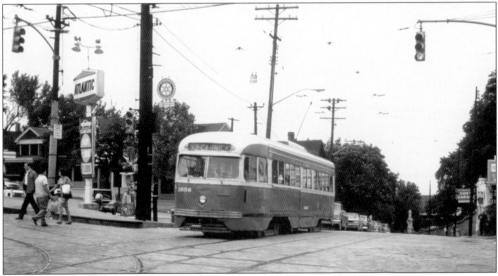

Presidents' Conference Committee car No. 1656 is at Carson Street and South Eighteenth Street on July 16, 1967, on Port Authority Transit route 53 Carrick. This double-tracked street-running line featured a long winding 8.42 percent grade up the South Eighteenth Street hill. During rush hours, route 47 Carrick via Tunnel used route 48 trackage to Arlington Avenue and Brownsville Road, and then route 53 trackage on Brownsville Road to Brentwood Loop. (Photograph by Kenneth C. Springirth.)

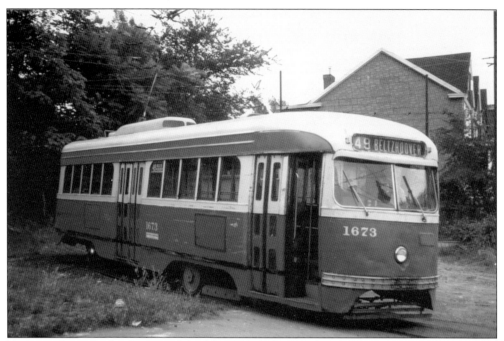

Turning the calendar back to July 16, 1967, finds Presidents' Conference Committee car No. 1673 at Port Authority Transit route 49 Beltzhoover Loop. Although this was a lightly used line, it played an important role as a bypass for the Mount Washington Trolley Tunnel. Its most scenic section was on Arlington Avenue, where the climb up the hill revealed a brilliant view of downtown Pittsburgh. (Photograph by Kenneth C. Springirth.)

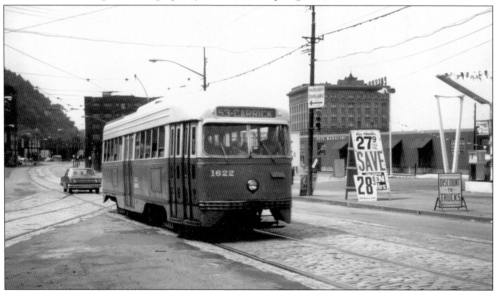

Presidents' Conference Committee car No. 1622 is on Carson Street at Arlington Avenue, heading east on Port Authority Transit route 53 on July 16, 1967. The tracks to the left of the trolley were for route 49 Beltzhoover, which was the bypass route for the Mount Washington Trolley Tunnel. The gas station on the right is advertising regular gas for 28.9¢ per gallon. (Photograph by Kenneth C. Springirth.)

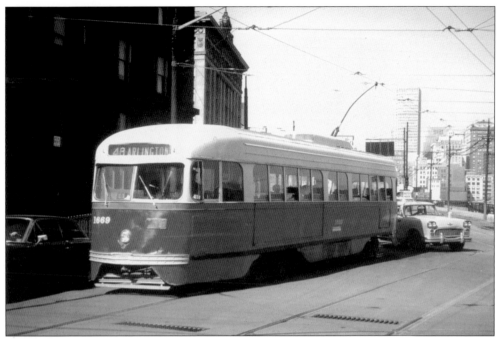

On March 30, 1968, Presidents' Conference Committee car No. 1669 is on Smithfield Street, ready to turn onto East Carson Street on the final day of trolley operation for route 48. Port Authority Transit eliminated route 48 and replaced it on March 31, 1968, by an extension of bus route 54A Arlington Heights. (Photograph by Kenneth C. Springirth.)

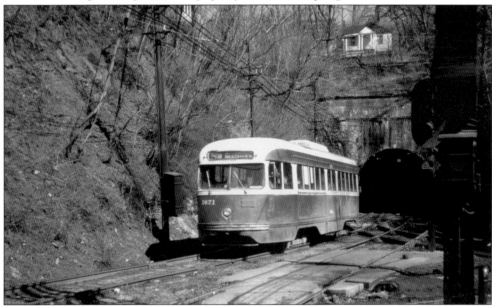

Emerging from the Mount Washington Trolley Tunnel is Presidents' Conference Committee car No. 1671 on route 42/38 on March 30, 1968. Trolley service to the township of Mount Lebanon began on December 1, 1904. Route 38 service to the borough of Castle Shannon, effective January 3, 1953, operated only during rush hours. On May 26, 1963, route 38 and route 42 were combined into route 42/38. (Photograph by Kenneth C. Springirth.)

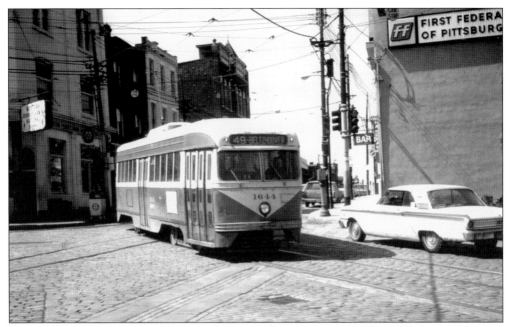

Presidents' Conference Committee car No. 1644 has just turned off East Warrington Avenue onto Arlington Avenue for the long descent into downtown Pittsburgh on March 30, 1968. Trackage going off to the left of the trolley was for route 48 Arlington, which was discontinued by Port Authority Transit on March 31, 1968. This trackage would be used by the rerouted route 53 beginning on March 31, 1968. (Photograph by Kenneth C. Springirth.)

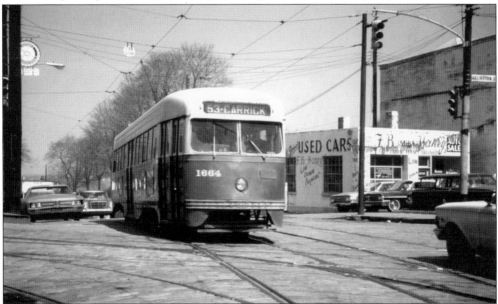

Following the long climb on South Eighteenth Street, Presidents' Conference Committee car No. 1664 has just crossed Arlington Avenue heading south on Brownsville Road, on Port Authority Transit route 53 to Brentwood Loop, on March 30, 1968. Trackage going off to the left was used by route 47 Carrick via Tunnel during rush hours, which effective on March 31, 1968, was then used by rerouted route 53. (Photograph by Kenneth C. Springirth.)

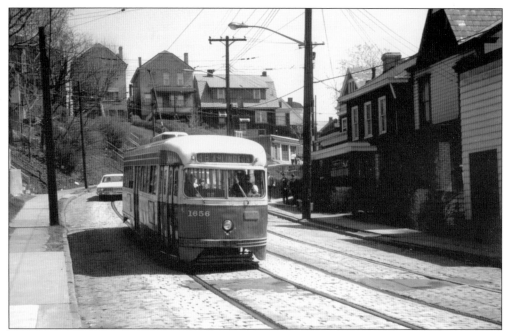

Arlington Avenue and Marengo Street provide the setting for Presidents' Conference Committee car No. 1656 on March 30, 1968, the last day of trolley operation for route 48 Arlington. This was a typical hill-and-dale Pittsburgh trolley car line. Port Authority Transit extended bus route 54A to cover the line beginning on March 31, 1968. (Photograph by Kenneth C. Springirth.)

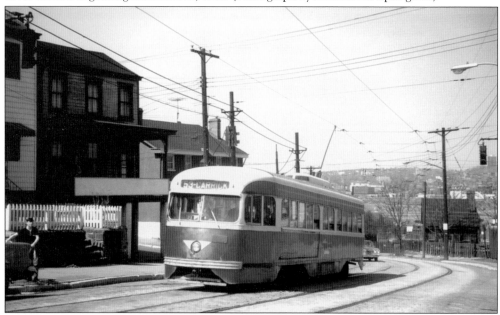

Efficiently coming up the long hill on South Eighteenth Street at Mission Street is Presidents' Conference Committee car No. 1637 heading south on Port Authority Transit route 53 Carrick on March 30, 1968. This was the last day for trolley car operation on South Eighteenth Street, as route 53 was rerouted on March 31, 1968, through the Mount Washington Trolley Tunnel, replacing the route 47 rush hour routing. (Photograph by Kenneth C. Springirth.)

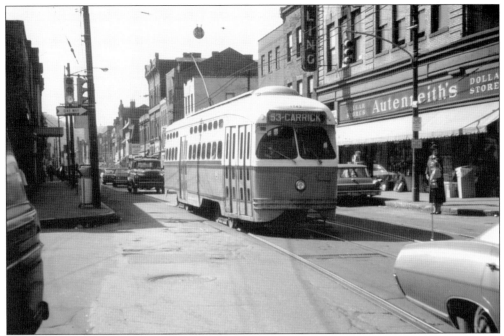

East Carson Street at South Seventeenth Street finds Presidents' Conference Committee car No. 1743 on Port Authority Transit route 53 on March 30, 1968. This was the last day for route 53 to operate on East Carson Street. Beginning March 31, 1968, route 53 operated through the Mount Washington Trolley Tunnel and Warrington Avenue, replacing rush hour trolley route 47. (Photograph by Kenneth C. Springirth.)

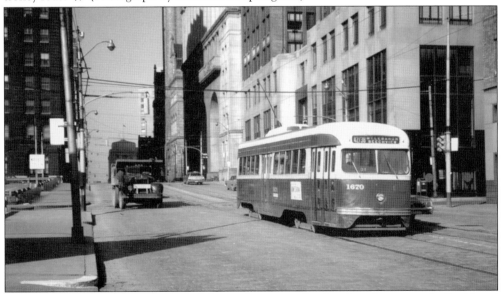

Grant Street at the Boulevard of the Allies in downtown Pittsburgh is the setting for Presidents' Conference Committee car No. 1670, operating on Port Authority Transit route 42/38 on March 30, 1968. This was the last day for trolley route 53 to operate on the Third Avenue and Fourth Avenue Loop in downtown Pittsburgh. Effective March 31, 1968, route 53 began operating over route 47 trackage. (Photograph by Kenneth C. Springirth.)

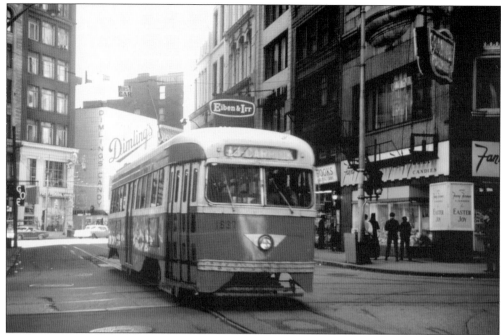

Presidents' Conference Committee car No. 1637 has turned off Liberty Avenue onto Wood Street and is crossing Sixth Avenue in downtown Pittsburgh on March 30, 1968. On March 31, 1968, Port Authority Transit rerouted route 53 through the Mount Washington Trolley Tunnel on route 47 trackage in downtown Pittsburgh. Before the rerouting, route 53 was the last trolley route using Second Avenue into downtown Pittsburgh. (Photograph by Kenneth C. Springirth.)

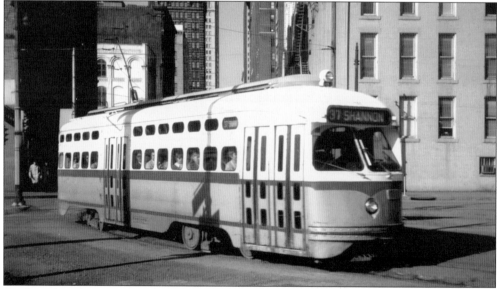

On Saturday afternoon, March 30, 1968, a 1700-series Presidents' Conference Committee car on route 37 is turning from Wood Street onto Fort Pitt Boulevard for the trip to Castle Shannon, which was a cutback loop for route 35 Library and route 36 Drake. During rush hour periods and Saturday afternoons, route 37 operated to and from Castle Shannon Loop. (Photograph by Kenneth C. Springirth.)

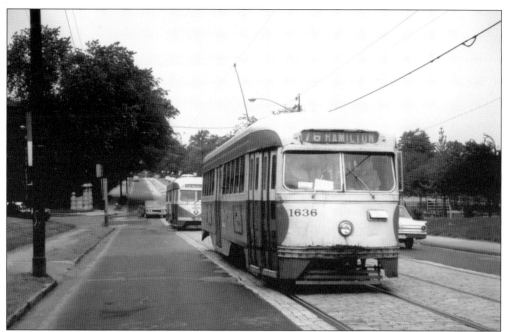

On a special trolley excursion held on May 26, 1968, Presidents' Conference Committee cars Nos. 1636 and 1646 are on Fifth Avenue west of Penn Avenue, on what had been used by route 76 Hamilton. Effective January 28, 1967, buses replaced all East End trolley routes, but trackage was retained to reach Homewood Shops. (Photograph by Kenneth C. Springirth.)

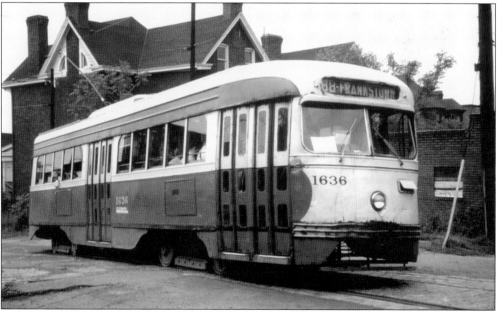

Tioga Loop is a photograph stop for Presidents' Conference Committee car No. 1636 on a May 26, 1968, trolley excursion. Trolley route 88 Frankstown was converted to bus operation by Port Authority Transit on January 28, 1967, and the entire East End of Pittsburgh no longer had regular trolley service, except for rail excursions and trips to and from Homewood Shops. (Photograph by Kenneth C. Springirth.)

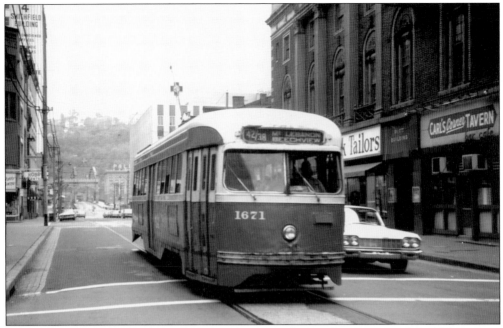

Smithfield Street at Third Avenue finds Presidents' Conference Committee car No. 1671 entering downtown Pittsburgh on Port Authority Transit route 42/38 Mount Lebanon via Beechview on May 26, 1968. Trolley routes 53 and 55–58 once had used Third Avenue, but now only buses traversed this roadway. (Photograph by Kenneth C. Springirth.)

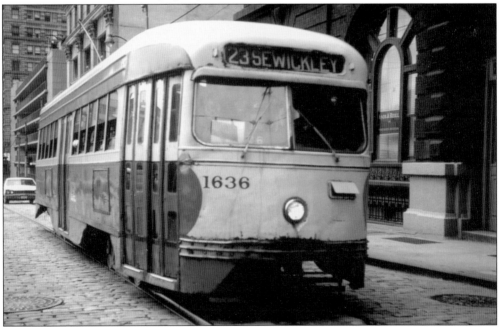

On Fourth Avenue at Grant Street, Presidents' Conference Committee car No. 1636, on a special trolley excursion, poses for a picture stop on May 26, 1968. Fourth Avenue was once a busy trolley stop served by trolley routes 53, 55–58, 64, and 67–69 but now was only a rush hour stop used by certain trips from Smithfield Street to Grant Street. (Photograph by Kenneth C. Springirth.)

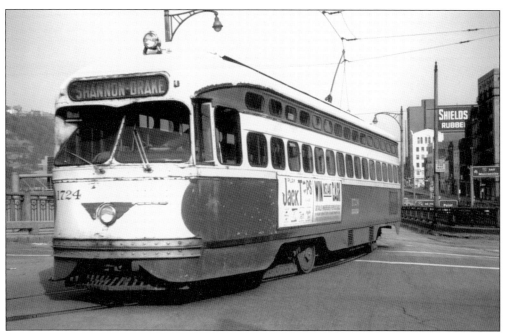

Presidents' Conference Committee car No. 1724 is turning from Fort Pitt Boulevard to Smithfield Street on Port Authority Transit route 36 Shannon-Drake on May 26, 1968. It is ready to cross the Monongahela River for its trip to southern Allegheny County. This trackage was still used by trolley routes 35–37, 44, 49, and 53. (Photograph by Kenneth C. Springirth.)

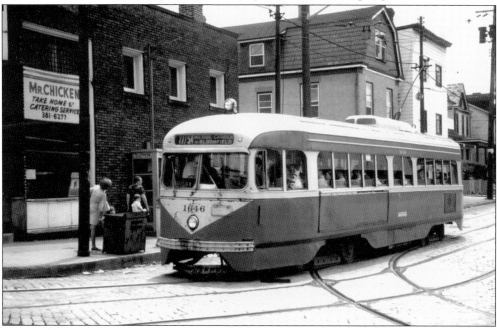

On Beltzhoover Avenue at Warrington Avenue, Presidents' Conference Committee car No. 1646, on a special trolley excursion, is actually on trackage used by routes 44 and 49, on May 26, 1968. Route 77/54, as seen on the front destination sign, never used this trackage, but actually operated east of this intersection. (Photograph by Kenneth C. Springirth.)

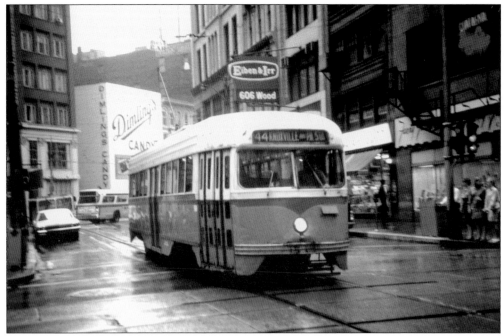

Amid the gentle rain of August 10, 1968, Presidents' Conference Committee car No. 1605, in the Port Authority Transit color scheme of white roof and upper half, gray lower section, and red trim, has turned from Liberty Avenue onto Wood Street and is crossing Sixth Avenue on route 44. This trackage was still used by trolley routes 35–37, 44, 49, and 53. (Photograph by Kenneth C. Springirth.)

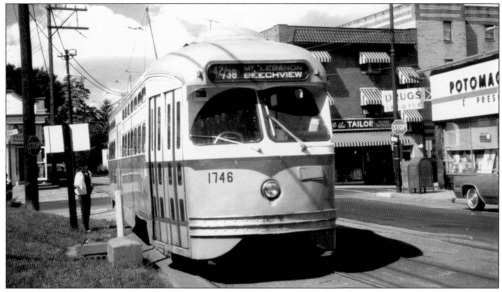

On August 10, 1968, Presidents' Conference Committee car No. 1746 is on Broadway Avenue at Potomac Avenue, part of Port Authority Transit route 42/38. On December 1, 1904, the Beechview line began operation between Castle Shannon and Pittsburgh, via Mount Lebanon and Dormont. On May 26, 1963, route 38 was combined with route 42 and became 42/38. (Photograph by Kenneth C. Springirth.)

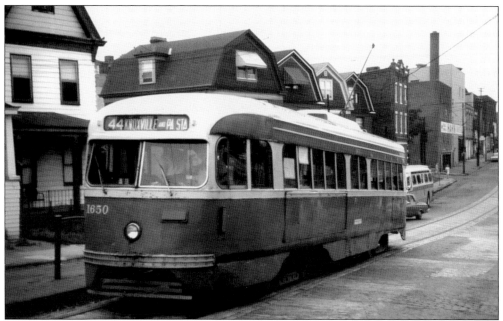

Route 44 Presidents' Conference Committee car No. 1650 is at Amanda and Charles Streets on August 10, 1968. After March 31, 1968, Port Authority Transit operated the following trolley routes: 35 Shannon-Library, 36 Shannon-Drake, 37 Shannon, 42/38A Castle Shannon via Mount Lebanon (rush hours only), 42 Dormont (rush hours only), 42/38 Mount Lebanon, 44 Knoxville, 49 Beltzhoover, and 53 Carrick. (Photograph by Kenneth C. Springirth.)

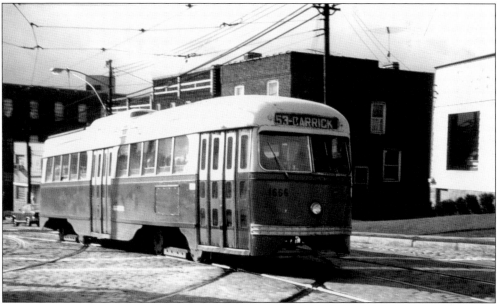

Port Authority Transit route 53 Presidents' Conference Committee car No. 1666 is eastbound on Warrington Avenue at Beltzhoover Avenue on October 26, 1968. By February 1971, the number of active Port Authority Transit trolley cars had been reduced to 118 at Tunnel Car House. Routes 44 and 49 trolleys used tracks seen in the lower left of the picture. (Photograph by Kenneth C. Springirth.)

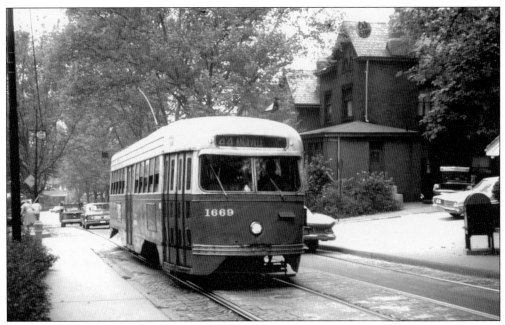

Charles Street at Georgia Avenue is the setting for route 44 Presidents' Conference Committee car No. 1669 on August 30, 1969. Saturday, June 28, 1969, was the last day for route 44 trolleys to loop around the Greyhound bus terminal via Penn Avenue in downtown Pittsburgh. Route 44 now turned left from Smithfield Street to Liberty Avenue and turned left onto Wood Street. (Photograph by Kenneth C. Springirth.)

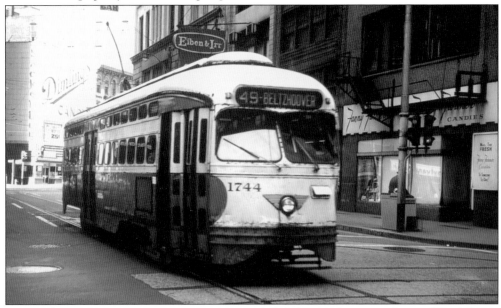

Port Authority Transit car No. 1744 on route 49 Beltzhoover has turned onto Wood Street from Liberty Avenue and is crossing Sixth Avenue, heading south in downtown Pittsburgh on August 8, 1971. Sixth Avenue was once a busy trolley corridor with routes 71, 73, 75, and 76 westbound on the northern track, while the southern track was used by routes 22, 82, and 85 eastbound. (Photograph by Kenneth C. Springirth.)

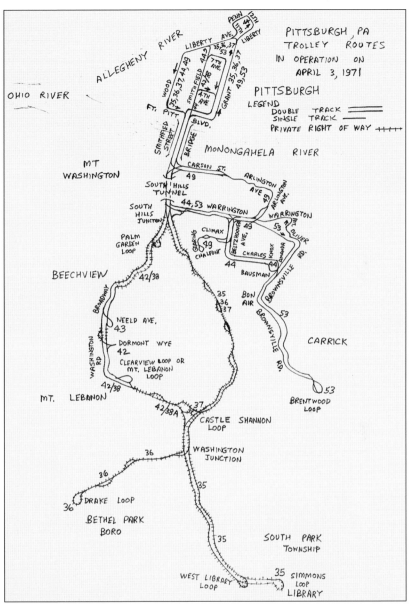

This map shows Port Authority Transit trolley routes operating as of April 3, 1971. Route 35 Library and 36 Drake each operated frequent rush hour service, with 30-minute midday service on weekdays and Saturday and 60-minute service on Sundays. Route 37 Shannon was a rush hour and Saturday afternoon cutback for routes 35 and 36. Route 42/38 Mount Lebanon operated frequent rush hour service, 12-minute service midday on weekdays and all day Saturday, and 20-minute Sunday service. Route 42/38A was the rush hour extension of route 42/38 to Castle Shannon. Route 44 Knoxville had 11-to-14-minute rush hour service, 15-to-22-minute midday service on weekdays, and 23-to-25-minute Saturday service. Evening and Sunday service was done by bus from South Hills Junction. Route 49 Beltzhoover had 30-minute rush hour service and 55-minute service at all other times. Late evening and early Sunday morning service was by bus. Route 53 Carrick had 5-to-10-minute rush hour service, 12-to-15-minute service midday and Saturday, and 20-minute evening and Sunday service.

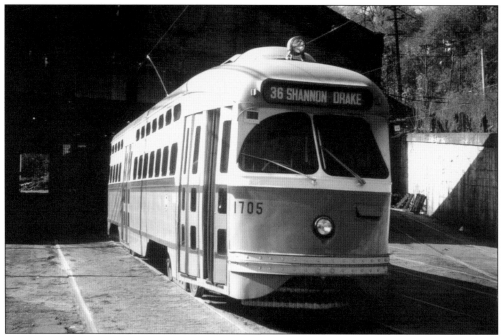

Presidents' Conference Committee car No. 1705 is at Tunnel Car House on October 30, 1971, in its Port Authority Transit color scheme of gray roof and lower sides, white window area, and red trim. This Presidents' Conference Committee car had sealed windows with a forced air ventilation system and was built by St. Louis Car Company for Pittsburgh Railways in 1948, at a cost of $28,350. (Photograph by Kenneth C. Springirth.)

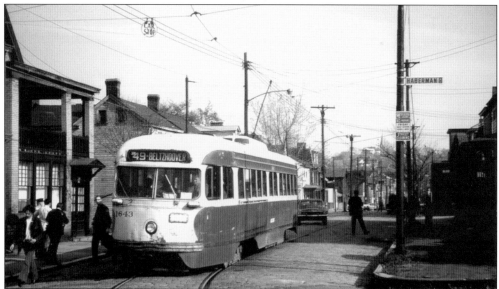

Car No. 1643, built at a cost of $20,000 by St. Louis Car Company in 1945, is operating on route 49 Beltzhoover in this November 13, 1971, last-trolley-day scene at Climax Street and Haberman Street. On November 14, 1971, Port Authority Transit converted trolley routes 49 Beltzhoover, 44 Knoxville, and 53 Carrick to bus operation. This car was later rehabilitated and renumbered as 1786. (Photograph by Kenneth C. Springirth.)

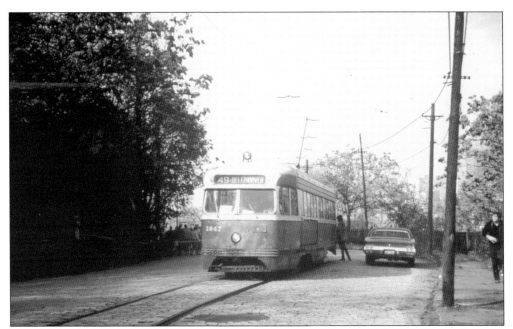

Presidents' Conference Committee car No. 1647 is on route 49 at Arlington Avenue, on its last day of trolley operation on November 13, 1971. Port Authority Transit converted routes 44, 49, and 53 to bus operation on November 14, 1971. The Arlington and Warrington Avenues trackage was retained as a bypass routing for the Mount Washington Trolley Tunnel and was designated route 49 Arlington-Warrington. (Photograph by Kenneth C. Springirth.)

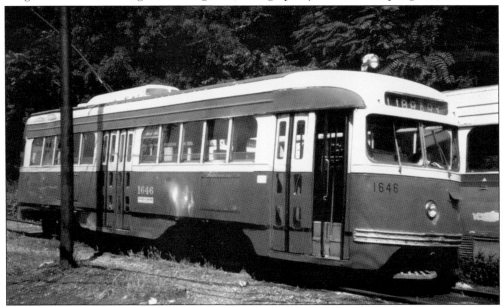

Tunnel Car House is the scene for Presidents' Conference Committee car No. 1646 on August 8, 1971. This car was equipped for interurban service by St. Louis Car Company for Pittsburgh Railways when it was placed in service in 1945, with its front roof headlight and cowcatcher. Port Authority Transit later refurbished this car and renumbered it as car No. 1781. (Photograph by Kenneth C. Springirth.)

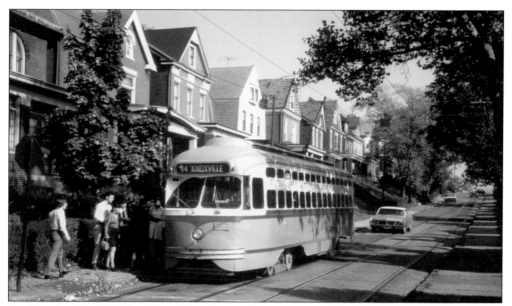

On October 30, 1971, Presidents' Conference Committee car No. 1773 is on Charles Street on route 44 Knoxville. On November 14, 1971, route 44 was replaced by bus route 46K, route 49 was replaced by bus route 46K, and route 53 was replaced by bus route 51C. Port Authority Transit established trolley route 49 using the Warrington and Arlington Avenues trackage as a tunnel bypass. (Photograph by Kenneth C. Springirth.)

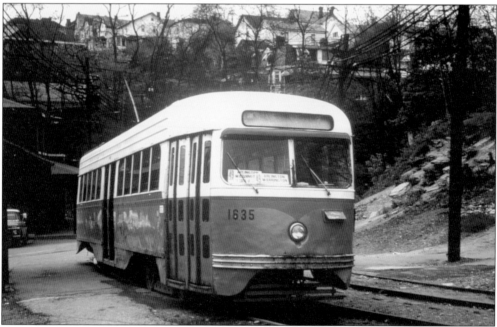

Presidents' Conference Committee car No. 1635 is shown at South Hills Junction on April 22, 1972, on the Port Authority Transit route 49 Arlington-Warrington, which served as a tunnel bypass line. In later years, this car was rehabilitated and renumbered as car No. 77/54, honoring the former route 77/54 trolley line. The bypass route later served to maintain trolley service during the rehabilitation of the Mount Washington Trolley Tunnel. (Photograph by Kenneth C. Springirth.)

Four

FINAL YEARS OF PRESIDENTS' CONFERENCE COMMITTEE TROLLEYS

On November 18, 1971, Port Authority Transit placed its first completely rebuilt Presidents' Conference Committee trolley in service at a cost of $250,000. As 12 cars were rebuilt, however, costs escalated and the project was stopped. During 1972, Port Authority Transit introduced a "mod" paint scheme on some of the 95 surviving Presidents' Conference Committee cars, with car No. 1730 redone in a psychedelic paint scheme. By 1979, advertising and message cars included Nos. 1703 and 1731, Burger King; No. 1704, Salvation Army; Nos. 1707, 1710, 1726, and 1746, Park-n-Ride; No. 1716, the Meadows; No. 1733, Robert Morris College; No. 1734, the Jolly Trolley; No. 1737, Volunteer Action Center; No. 1744, Freight House Shops; Nos. 1745 and 1751, Budweiser; No. 1747, Castle Shannon Volunteer Fire Department; No. 1754, WPGH Channel 53; No. 1756, Pittsburgh Opportunities Industrialization Center; No. 1761, United Cerebral Palsy; No. 1763, Pittsburgh Paints; No. 1764, South Hills High School; No. 1769, Civil Air Patrol; No. 1771, Point Park College; No. 1776, the Spirit of 1776; No. 1779, Trans World Airlines; No. 1780, Junior Achievement; No. 1783, Allentown Hilltop Civic Improvement Association; No. 1790, United Way; No. 1791, Happy Birthday America; No. 1794, Triple Treat boat trolley; No. 1796, *Mister Rogers' Neighborhood*; No. 1976, KDKA Radio 1020; and No. 77/54, the Flyin' Fraction. By 1981, there were additional special painted cars, including No. 1738, Jenkins Arcade; No. 1713, the Terrible Trolley; No. 1718, Cash Stream; No. 1742, Clark Bar; No. 1724, Don't Leave Home Without Us; No. 1752, Recycle Aluminum; No. 1729, Pittsburgh National Bank; and No. 1766, This Is the Army. On June 6, 1993, the Overbrook trolley line was closed due to deteriorated bridges and track. Funding was not yet available to rebuild that line. Presidents' Conference Committee cars were now confined to the route 47D Drake Shuttle, which operated from Drake Loop to Castle Shannon. On September 4, 1999, Presidents' Conference Committee cars made their final public runs on the route 47D Drake Shuttle, and the three surviving cars made a special excursion run on both the Drake Shuttle and Library line on September 5, 1999.

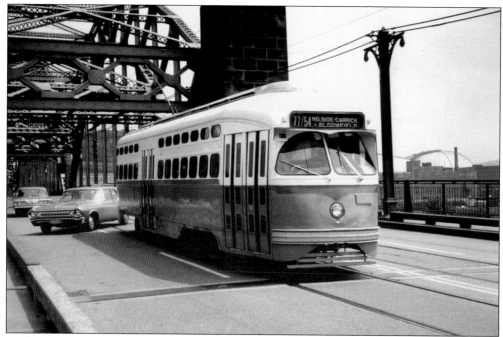

In this June 7, 1964, scene, three months after the Port Authority Transit takeover, Presidents' Conference Committee car No. 1797 is coming over the Sixteenth Street Bridge over the Allegheny River on route 77/54. On July 8, 1963, Pittsburgh Railways Company discontinued service over the Brady Street Bridge to the South Side, and the line operated from the North Side to Forbes Avenue and Gist Street. (Photograph by Kenneth C. Springirth.)

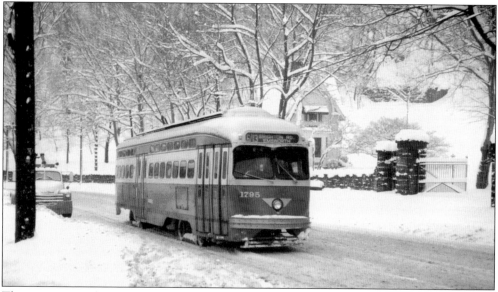

The snowstorm of January 23, 1966, finds Presidents' Conference Committee car No. 1795 on Brighton Road. On December 31, 1965, Port Authority Transit ended trolley service between Emsworth and Avalon Loop, and route 6 was combined with route 14, becoming route 6/14. The number of active trolley cars declined from 288 on March 1, 1964, to 212 by the end of 1966. (Photograph by Kenneth C. Springirth.)

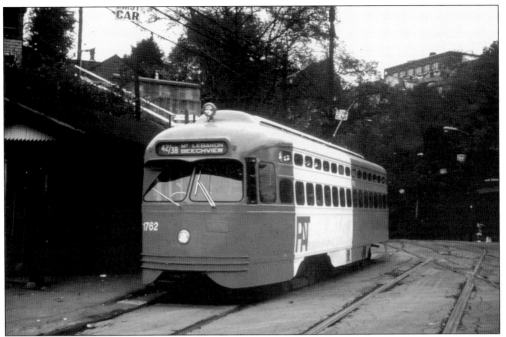

Presidents' Conference Committee car No. 1762 is passing through South Hills Junction on October 21, 1972. Marking a new era, this car was repainted by Port Authority Transit (in red with a white center section), along with car No. 1767 (orange with a white center section), car No. 1744 (yellow with a white center section), and car No. 1730 (psychedelic sunburst). (Photograph by Kenneth C. Springirth.)

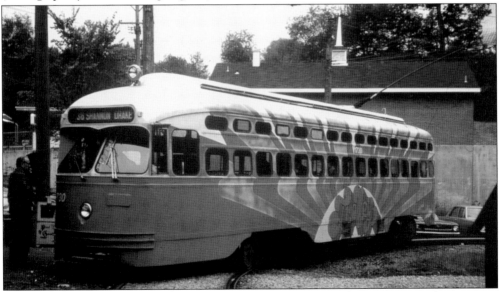

Car No. 1730 is at the route 36 Drake Loop in southern Allegheny County on October 21, 1972, with a painted psychedelic sunburst. On July 26, 1972, four repainted trolley cars (Nos. 1730, 1744, 1762, and 1767) paraded through downtown Pittsburgh, offering free rides. Port Authority Transit's new "mod" paint scheme, along with service improvements, increased ridership. (Photograph by Kenneth C. Springirth.)

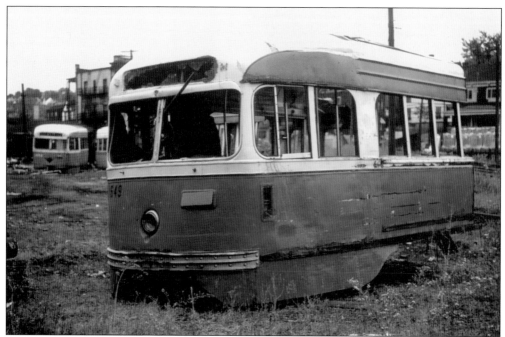

In this November 15, 1972, view, Presidents' Conference Committee car No. 1649 has been cut apart at South Hills Junction in the special section for cars to be scrapped. The Port Authority Transit fleet of active trolley cars was reduced from 118 on February 13, 1971, to 95 by October 1972. (Photograph by Kenneth C. Springirth.)

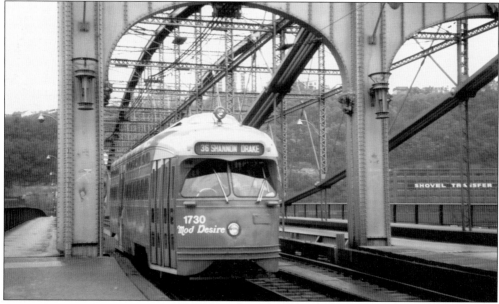

On May 27, 1973, Port Authority Transit route 36 Presidents' Conference Committee car No. 1730 is northbound for downtown Pittsburgh, crossing the Monongahela River over the 1,184-foot Smithfield Street Bridge. The bridge, designed by Gustav Lindenthal and completed in 1883, was a lenticular truss bridge, which has the configuration of a lens. (Photograph by Kenneth C. Springirth.)

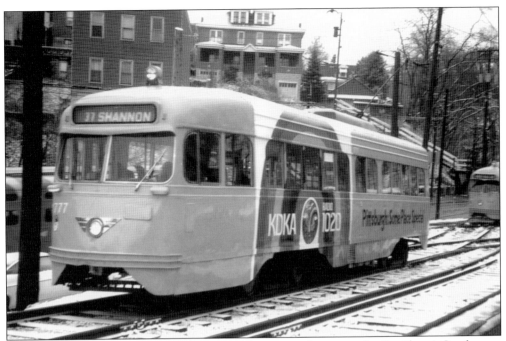

South Hills Junction, with a light dusting of snow, is the scene for Presidents' Conference Committee car No. 1777 on April 9, 1974. This was originally car No. 1615 and was refurbished by Port Authority Transit, advertising a Pittsburgh radio station. A total of 25 cars from the 1600 series were refurbished. (Photograph by Kenneth C. Springirth.)

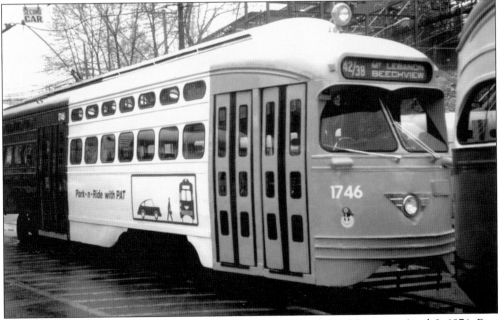

Presidents' Conference Committee car No. 1746 is at Tunnel Car House on April 9, 1974. Port Authority Transit advertised, "Park-n-Ride with PAT." The car front was yellow, the center section was white with green lettering, and the rear section was green. The goal of painting the trolleys in bright colors was to enhance the image of public transit. (Photograph by Kenneth C. Springirth.)

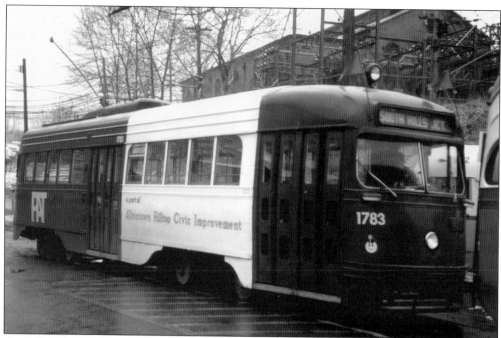

April 9, 1974, finds Presidents' Conference Committee car No. 1783 parked at Tunnel Car House, ready for service advertising, "a part of Allentown Hilltop Civic Improvement." This was originally car No. 1636 and was refurbished by Port Authority Transit. The car's front and rear were green, and the center section was white. (Photograph by Kenneth C. Springirth.)

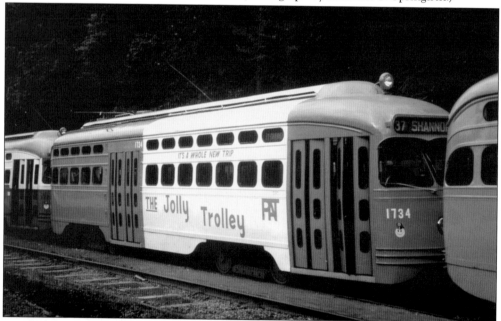

Car No. 1734, with the message "The Jolly Trolley," is in the line up of cars at Tunnel Car House on September 22, 1974. The front and rear of the car were painted magenta, and the section between the front and center doors was white. Port Authority Transit had an amazing variety of attractive paint schemes. (Photograph by Kenneth C. Springirth.)

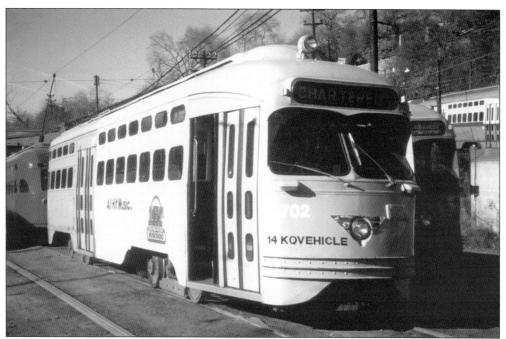

Presidents' Conference Committee car No. 1702 is at Tunnel Car House waiting for the next assignment on October 27, 1974. This car was redone with a light blue front and rear, with a white center section advertising a Pittsburgh radio station. Port Authority Transit's repainting program resulted in a variety of attractive and eye-catching trolleys. (Photograph by Kenneth C. Springirth.)

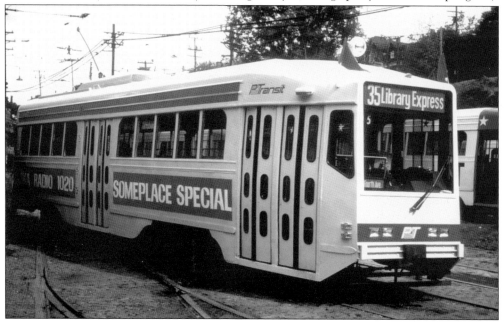

Car No. 1781 is parked at Tunnel Car House at South Hills Junction on April 21, 1975, advertising that Pittsburgh is someplace special. This was originally car No. 1646, and Port Authority Transit refurbished it with a new European-style flat front and a large one-piece windshield. The car was painted cream with red trim and white side lettering. (Photograph by Kenneth C. Springirth.)

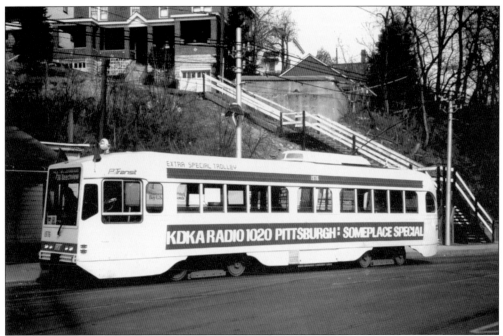

"Extra Special Trolley" car No. 1976 is making a stop at South Hills Junction on February 28, 1976. This car was put into service on September 2, 1975, having been rebuilt from accident-damaged car No. 1784, which was originally car No. 1603. The car featured a flat front with a one-piece windshield, oversize destination sign, and turn signals. The exterior was painted cream and red. (Photograph by Kenneth C. Springirth.)

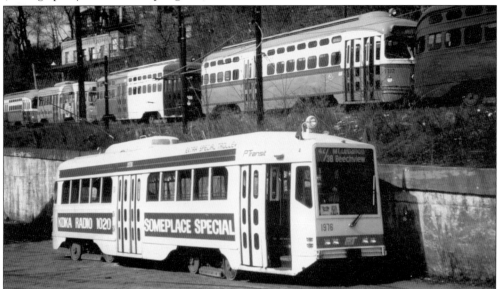

Tunnel Car House on February 28, 1976, is a colorful sight with Presidents' Conference Committee car No. 1976 ready for service, amid the lineup of trolleys in a variety of paint schemes. Since the first brightly painted trolleys made their debut on July 26, 1972, Port Authority Transit had a large percentage of trolleys painted like rolling billboards by 1976. (Photograph by Kenneth C. Springirth.)

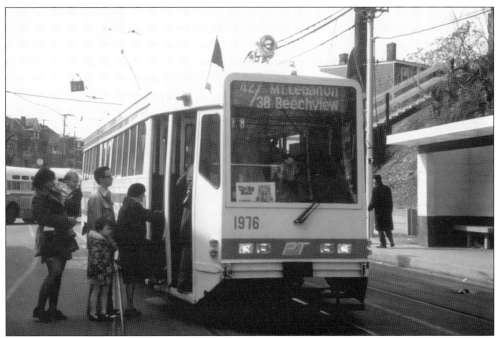

South Hills Junction finds Port Authority Transit route 42/38 Presidents' Conference Committee car No. 1976 loading passengers on February 28, 1976, heading north for downtown Pittsburgh. The trolley car repainting program made transit riding an attractive experience, which resulted in increased ridership. (Photograph by Kenneth C. Springirth.)

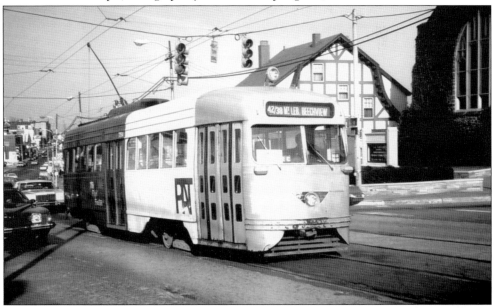

Presidents' Conference Committee car No. 77/54 is on Washington Road at Scott Road in the township of Mount Lebanon on February 28, 1976. Port Authority Transit rehabilitated this car, which was originally No. 1635, with a yellow front, white center section, and blue rear section. The car honored route 77/54, known as the "Flying Fraction" line, which operated from the North Side to the South Side. (Photograph by Kenneth C. Springirth.)

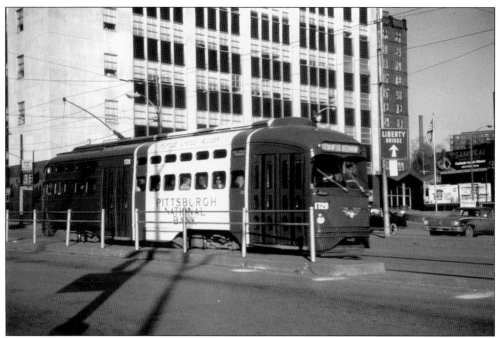

Heading southbound on Grant Street at First Avenue is Presidents' Conference Committee car No. 1729 on route 42/38 on February 28, 1976. This car had been repainted by Port Authority Transit with a blue front and rear and white center section having two narrow bands of red with the advertisement for a Pittsburgh bank. (Photograph by Kenneth C. Springirth.)

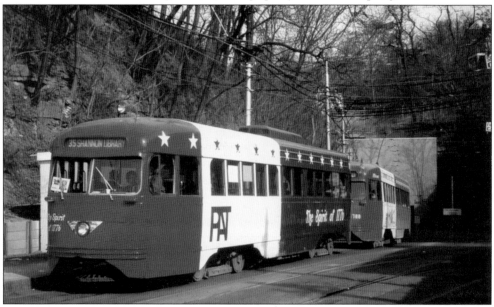

In a bicentennial paint scheme for the 200th anniversary of the United States, Presidents' Conference Committee cars Nos. 1776 (formerly car No. 1616) and 1788 (formerly car No. 1639) are at South Hills Junction on February 28, 1976. Both cars had been refurbished by the Port Authority Transit with new interiors, chromed front headlight wings, and an attractive exterior paint scheme. (Photograph by Kenneth C. Springirth.)

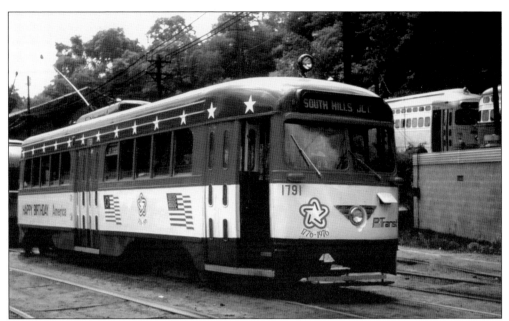

"Happy Birthday America" is the theme on Presidents' Conference Committee car No. 1791, with its blue roof and bottom, red window area, and white lower section, ready for service at Tunnel Car House on July 4, 1976. This was originally car No. 1656 and was rehabilitated by Port Authority Transit. (Photograph by Kenneth C. Springirth.)

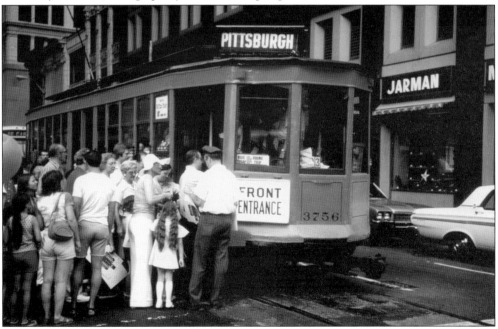

Former Pittsburgh Railways car No. 3756, on loan from the Arden Trolley Museum, is running a special bicentennial downtown Pittsburgh trolley loop on July 4, 1976. Osgood Bradley Car Company built this single-end, low-floor car in 1925. On February 7, 1954, the Pittsburgh Electric Railway Club moved this car, along with two others, to its newly established trolley museum in Arden. (Photograph by Kenneth C. Springirth.)

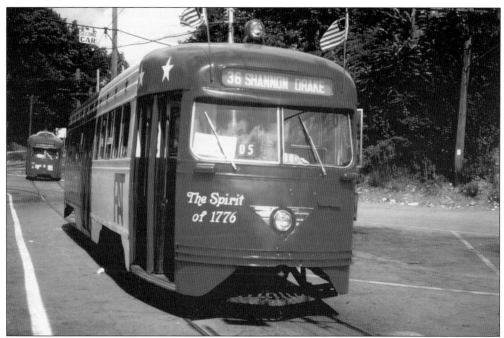

Presidents' Conference Committee car No. 1776 is on the layover track at South Hills Junction on July 18, 1976. The car, refurbished by Port Authority Transit, featured a red front, white middle section, and blue rear section. Car No. 1704 is behind it, advertising a fast-food restaurant. (Photograph by Kenneth C. Springirth.)

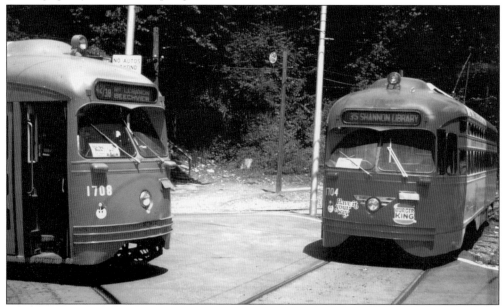

South Hills Junction is the scene for Presidents' Conference Committee cars Nos. 1708 and 1704 on July 18, 1976. On March 4, 1976, a transit consultant's report recommended light-rail technology for the South Hills trolley lines of Port Authority Transit and concluded that a new light-rail system would provide the greatest amount of convenient transit service for the dollar invested. (Photograph by Kenneth C. Springirth.)

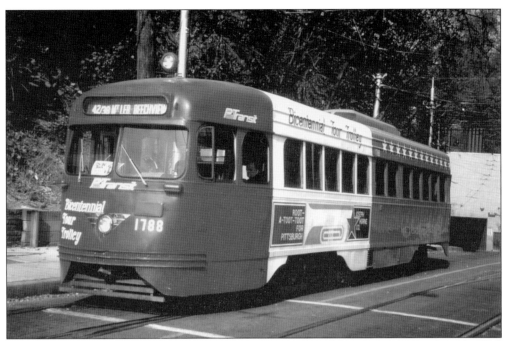

Bicentennial Tour Trolley car No. 1788 is shown at South Hills Junction on October 23, 1976, heading south on route 42/38 Mount Lebanon Beechview. This was originally car No. 1639 and was attractively refurbished with a red front, white midsection (with the words "Root-A-Toot-Toot for Pittsburgh"), and blue rear section. (Photograph by Kenneth C. Springirth.)

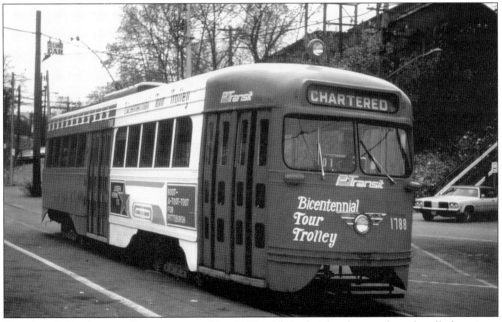

Presidents' Conference Committee car No. 1788, with its bright chrome front headlight wings, is shown at South Hills Junction on October 30, 1976, for a chartered trip. Cars numbered 1776 and higher were rebuilt by Port Authority Transit and were renumbered from the original 1600 series of cars. (Photograph by Kenneth C. Springirth.)

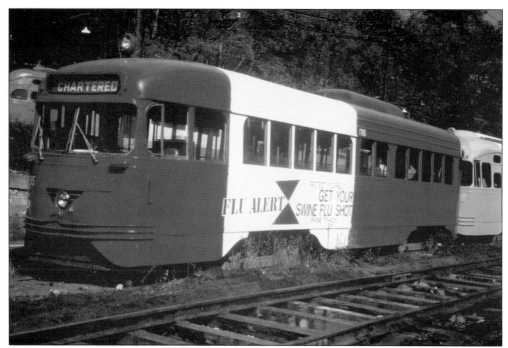

Presidents' Conference Committee car No. 1785 is located at Tunnel Car House on October 23, 1976. Port Authority Transit had refurbished this car, which was originally car No. 1637, into a message car with a red front and rear and white center section calling attention to a flu alert in red letters stating, "Protect Yourself: Get Your Swine Flu Shot." (Photograph by Kenneth C. Springirth.)

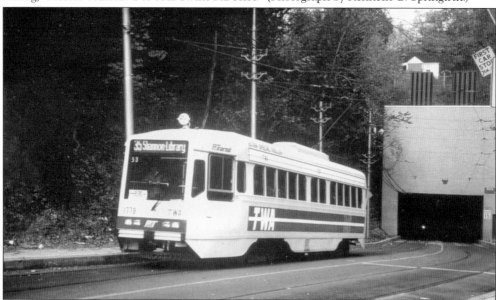

South Hills Junction is the scene for Presidents' Conference Committee car No. 1779, having emerged from the Mount Washington Trolley Tunnel on October 23, 1976. This was originally car No. 1647 and was rebuilt by Port Authority Transit with a flat front to simulate a modern light-rail vehicle. Between 1973 and 1975, the Mount Washington Trolley Tunnel was rebuilt for joint trolley and bus operation. (Photograph by Kenneth C. Springirth.)

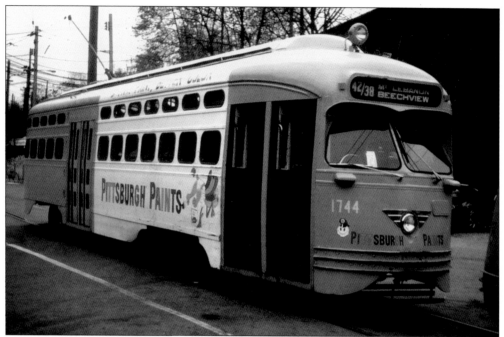

Presidents' Conference Committee car No. 1744, with a yellow front and rear and white center section advertising paint, is at South Hills Junction on October 30, 1976, heading north for downtown Pittsburgh via route 42/38. By 1976, Port Authority Transit had more special paint schemes for trolleys than any other North American trolley system. (Photograph by Kenneth C. Springirth.)

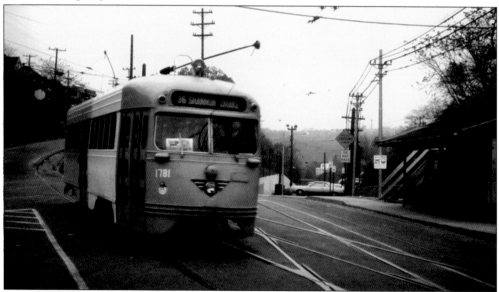

October 30, 1976, finds Presidents' Conference Committee car No. 1781 (originally car No. 1646) heading north into South Hills Junction. Trackage to the right of the trolley was for route 42/38, which was set in pavement through Tunnel Car House for the four-mile bus route between Pittsburgh and Overbrook that also included reconstruction of the Mount Washington Trolley Tunnel for joint trolley and bus operation. (Photograph by Kenneth C. Springirth.)

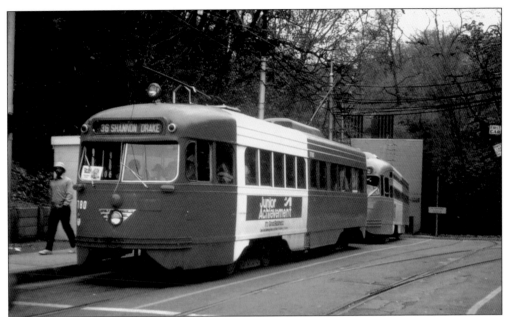

Presidents' Conference Committee car No. 1780 is at South Hills Junction on October 30, 1976, for a southbound trip on route 36 Shannon-Drake. This originally was car No. 1619 and was rehabilitated by Port Authority Transit, with a red front and rear and a white center section highlighting "Junior Achievement." The front pole was added to permit operation from the back end of the car. (Photograph by Kenneth C. Springirth.)

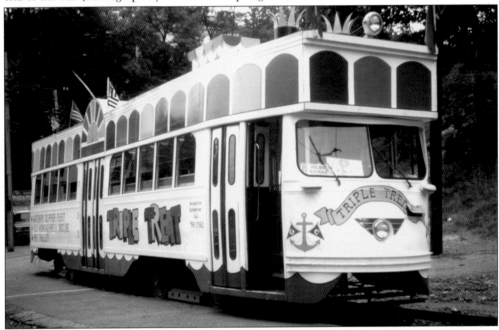

Triple Treat boat trolley No. 1794 (original car No. 1669) is at South Hills Junction on August 13, 1977. Port Authority Transit refurbished this car to have the appearance of a boat. Because of the fabricated smokestack on the roof, it could not clear the South Hills Tunnel and was confined to route 49, the tunnel bypass line. (Photograph by Kenneth C. Springirth.)

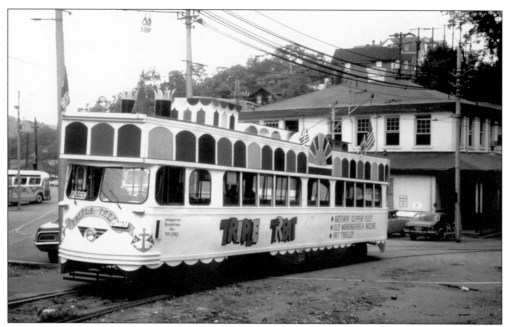

The Triple Treat boat trolley is at South Hills Junction on August 13, 1977. In July 1977, Port Authority Transit and the Golden Clipper Fleet introduced a $3.50 tour that began with a trip on the Gateway Clipper Fleet at the Monongahela River Wharf. Afterward passengers crossed the Smithfield Street Bridge by trolley and rode up and down the Monongahela Incline. Passengers boarded another trolley for downtown Pittsburgh. (Photograph by Kenneth C. Springirth.)

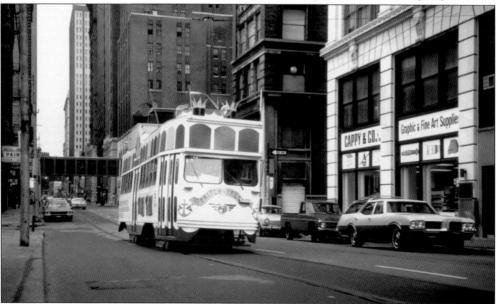

Southbound on Wood Street, the Triple Treat boat trolley has just crossed First Avenue and is coming up to Fort Pitt Boulevard with the West Penn Building on the right side of picture on August 13, 1977. The car featured marker lights, smokestacks, assorted flags, and an imitation life preserver, making it a unique vehicle produced by Port Authority Transit. (Photograph by Kenneth C. Springirth.)

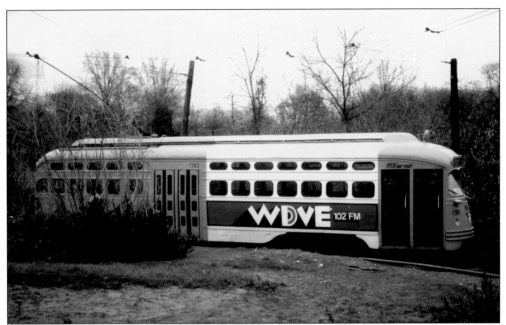

Presidents' Conference Committee car No. 1763 is at the Port Authority Transit route 42/38 loop in Mount Lebanon on November 5, 1977. Port Authority Transit repainted this car with a yellow front and rear and a white center section that advertised a Pittsburgh radio station. During rush hours, certain trips operated beyond this loop to Castle Shannon. (Photograph by Kenneth C. Springirth.)

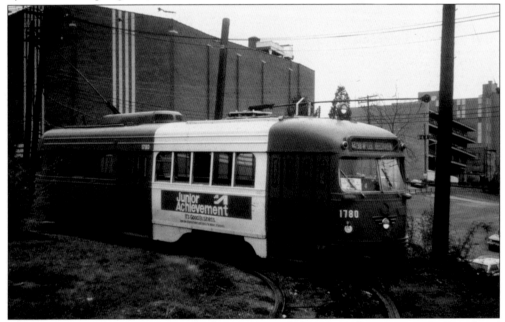

The Port Authority Transit route 42/38 loop at Mount Lebanon is a layover point for Presidents' Conference Committee car No. 1780 on November 5, 1977. This was the classic Pittsburgh trolley route, with track in the street, private right-of-way, and operation through the Mount Washington Trolley Tunnel. (Photograph by Kenneth C. Springirth.)

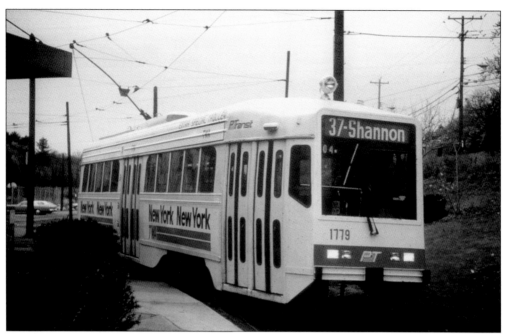

Presidents' Conference Committee car No. 1779, advertising Trans World Airlines, is at Castle Shannon Loop on November 5, 1977. Port Authority Transit rehabilitated this car, which was originally car No. 1647, and fashioned a new flat front. The car had a one-piece windshield, oversize destination sign, and turn signals, and the exterior was painted cream and red. (Photograph by Kenneth C. Springirth.)

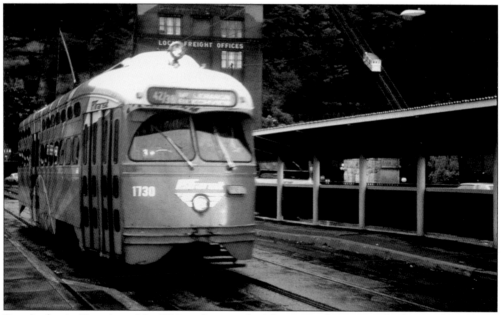

Port Authority Transit car No. 1730, with its psychedelic paint scheme, is at the Station Square stop on Smithfield Street, with the Monongahela Incline shown in the upper right, on July 21, 1980. This trackage was abandoned on July 3, 1985, after which trolleys were moved to the Panhandle Bridge and into a downtown subway. (Photograph by Kenneth C. Springirth.)

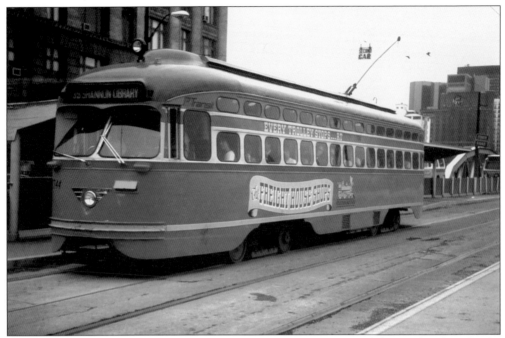

Port Authority Transit car No. 1744 is on Smithfield Street, in front of the Pittsburgh and Lake Erie train station on July 21, 1980. This car is advertising, "Every Trolley Stops . . . at the Freight House Shops." The trolley was attractively painted with a black roof, orange sides, and yellow trim. (Photograph by Kenneth C. Springirth.)

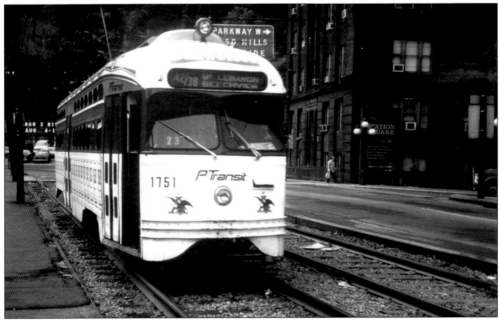

Smithfield Street, just north of Carson Street, is the scene for Presidents' Conference Committee car No. 1751, advertising a familiar beverage on its northbound trip into downtown Pittsburgh on route 42/38 on July 21, 1980. All of the remaining Port Authority Transit trolley lines used this trackage. (Photograph by Kenneth C. Springirth.)

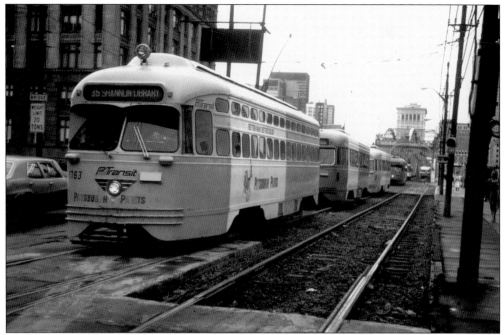

The afternoon rush hour of July 21, 1980, finds Presidents' Conference Committee car No. 1763 advertising a famous paint company on Smithfield Street near Carson Street, with the Pittsburgh and Lake Erie Railroad passenger station on the left. The lineup of cars, with each one painted a different color, demonstrated the goal of Port Authority Transit to create a pleasing visual experience for public transit. (Photograph by Kenneth C. Springirth.)

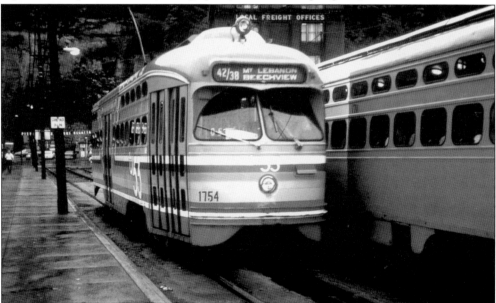

Northbound Presidents' Conference Committee car No. 1754 is on Smithfield Street, north of Carson Street, on route 42/38 heading for downtown Pittsburgh, with the Pittsburgh and Lake Erie Railroad local freight house behind the trolley. Port Authority Transit repainted this car to advertise Pittsburgh's WPGH Channel 53 television station. (Photograph by Kenneth C. Springirth.)

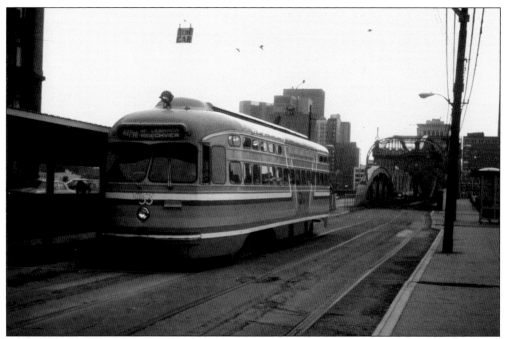

Port Authority Transit route 42/38 Presidents' Conference Committee car No. 1754 has crossed the Smithfield Street Bridge over the Monongahela River and is heading south to the township of Mount Lebanon on July 21, 1980. Painted blue with a rainbow of colors in the lower body section, the car advertised Pittsburgh television station WPGH. (Photograph by Kenneth C. Springirth.)

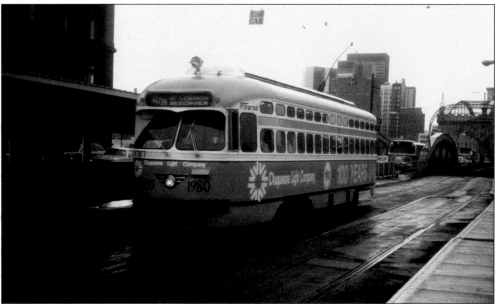

Presidents' Conference Committee car No. 1767 on Port Authority Transit route 42/38 is pulling into the Station Square stop on July 21, 1980, heading south to the township of Mount Lebanon. The trolley, repainted to commemorate the 100th anniversary of the Duquesne Light Company, had crossed the Smithfield Street Bridge over the Monongahela River. (Photograph by Kenneth C. Springirth.)

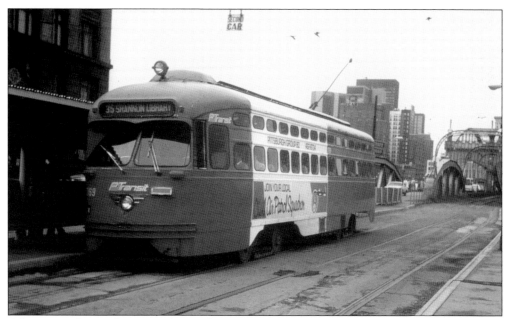

Advertising the Civil Air Patrol, Presidents' Conference Committee car No. 1769 is gliding into the Station Square stop on its outbound trip on route 35 Shannon-Library on July 21, 1980. With the skyline view of downtown Pittsburgh in the background, Smithfield Street from Carson Street to Fort Pitt Boulevard was an ideal area to photograph the surviving Port Authority Transit trolley routes. (Photograph by Kenneth C. Springirth.)

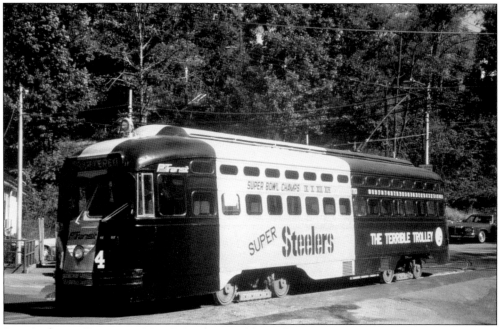

Port Authority Transit car No. 1713, "the Terrible Trolley," is on a passenger stop at South Hills Junction on October 11, 1980. With the front and rear in black and the section between the front and center doors in yellow, this car highlights that the Pittsburgh Steelers are Super Bowl champs. (Photograph by Kenneth C. Springirth.)

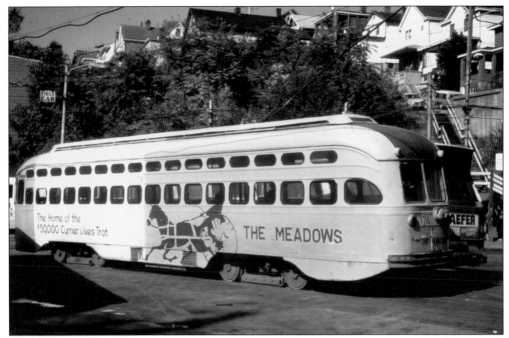

Presidents' Conference Committee car No. 1716 is at South Hills Junction on October 11, 1980. Port Authority Transit repainted this car with a yellow front and rear and a white center section. The car advertises the Meadows racetrack with brown lettering. A large percentage of the trolley cars were in special paint schemes. (Photograph by Kenneth C. Springirth.)

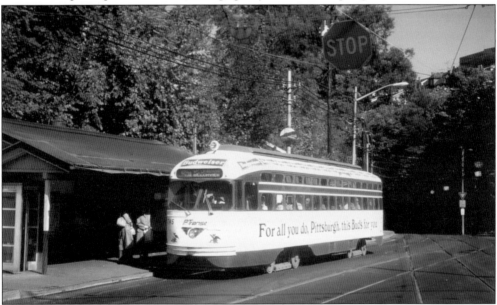

Presidents' Conference Committee car No. 1745 has arrived at South Hills Junction on route 42/38 on October 11, 1980. The advertising car was white with red striping. On May 7, 1979, Port Authority Transit was awarded $265 million from the United States Urban Mass Transportation Administration for final design and construction of Stage I on the light-rail system, which would modernize the trolley system. (Photograph by Kenneth C. Springirth.)

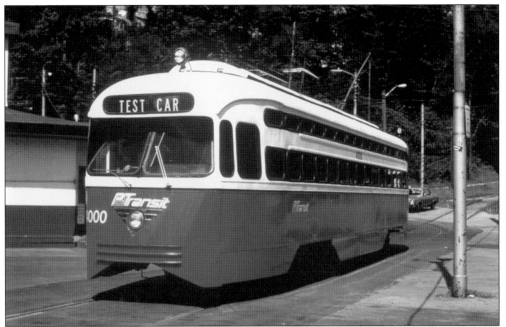

On July 30, 1981, Presidents' Conference Committee car No. 4000 is at South Hills Junction on a test run. The *Pittsburgh Post Gazette* of November 19, 1981, noted, "Car No. 4000 is the product of mechanics at the South Hills Junction streetcar maintenance shop. They used the basic frame of car No. 1702 and rebuilt it." (Photograph by Kenneth C. Springirth.)

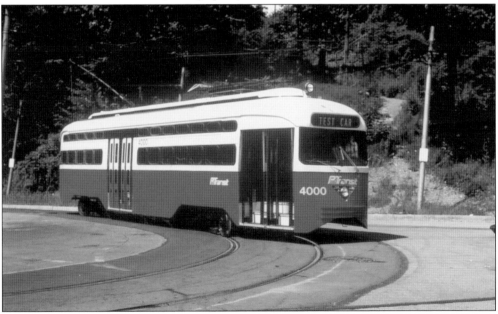

Port Authority Transit's completely rebuilt Presidents' Conference Committee car No. 4000 is at South Hills Junction on July 30, 1981. Practically every component part was replaced. At an estimated $250,000, the car was retrofitted with new windows, doors, steps, a heating and ventilation system, fluorescent lights, motors, a wiring control panel, floor covering, and seats. (Photograph by Kenneth C. Springirth.)

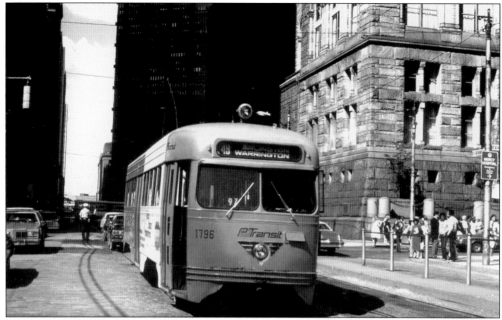

Presidents' Conference Committee car No. 1796 is on Grant Street and has just crossed Forbes Avenue in downtown Pittsburgh on July 30, 1981, with the Allegheny County Court House on the right. This was originally car No. 1638 and was painted orange on the front and rear and had a white center section that advertised the popular television show *Mister Rogers' Neighborhood*, hosted by Fred Rogers. (Photograph by Kenneth C. Springirth.)

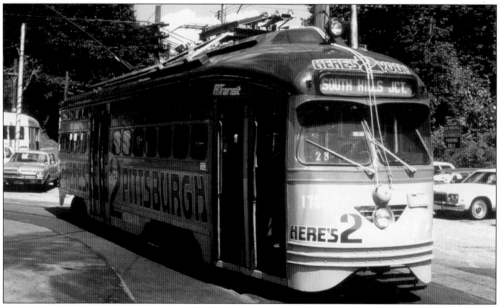

"Here's 2 Pittsburgh" is the attractive advertisement on Presidents' Conference Committee car No. 1761 at South Hills Junction on July 30, 1981. Port Authority Transit painted this car with a dark blue upper body and roof section and light blue on the lower body section. The car also featured a new pantograph mounted on the roof, which would take the place of the trolley pole. (Photograph by Kenneth C. Springirth.)

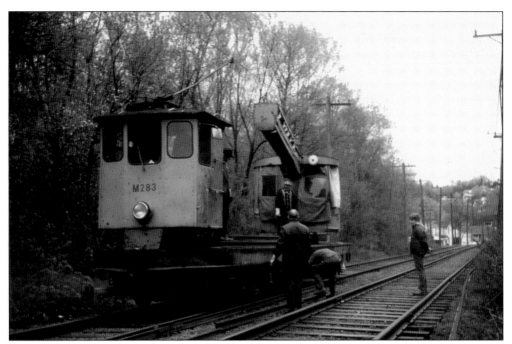

Port Authority Transit crane car No. M283 is being used to place rail along the Library line on April 25, 1981. This work car was built by Differential Car Company for Pittsburgh Railways in 1927 and was rehabilitated during 1973. The car was designed to work under trolley wire and could swing in a complete circle. This car is now at the Pennsylvania Trolley Museum. (Photograph by Kenneth C. Springirth.)

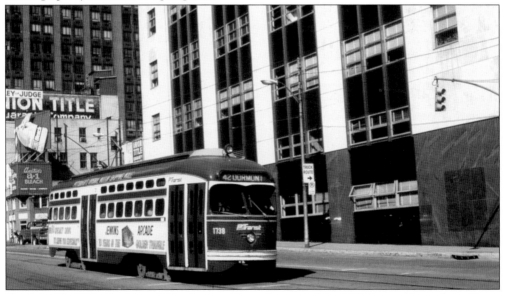

On July 30, 1981, Presidents' Conference Committee car No. 1738 is southbound on Grant Street having just crossed the Boulevard of the Allies. Route 42 Dormont was a rush hour run that did not go through to the township of Mount Lebanon. The car, advertising the Jenkins Arcade, had a green roof and front, with a white lower section trimmed with green and yellow striping. (Photograph by Kenneth C. Springirth.)

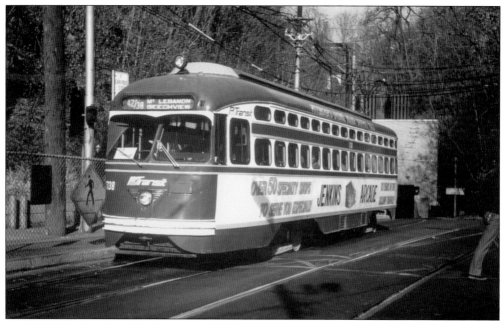

Presidents' Conference Committee car No. 1738 is at South Hills Junction southbound on Port Authority Transit route 42/38 for Mount Lebanon on November 14, 1981. Groundbreaking for the 1.1-mile downtown Pittsburgh subway occurred on October 19, 1981. To permit the rebuilding of Warrington Avenue, the route 49 Arlington-Warrington trolley closed on June 12, 1982, and reopened as route 52 Allentown on July 7, 1985. (Photograph by Kenneth C. Springirth.)

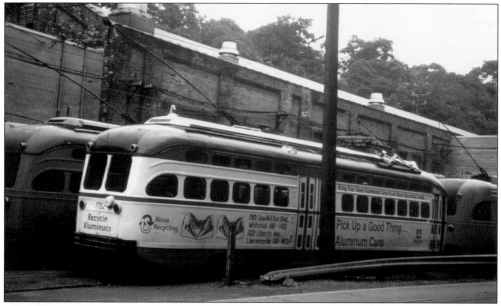

Tunnel Car House is the setting for Presidents' Conference Committee car No. 1752, in the lineup of Port Authority Transit cars on June 19, 1982. This message car focused on the recycling of aluminum cans. The roof and upper standee windows were dark blue, and the remainder of the car was white with a horizontal red stripe below the windows highlighted by blue lettering. (Photograph by Kenneth C. Springirth.)

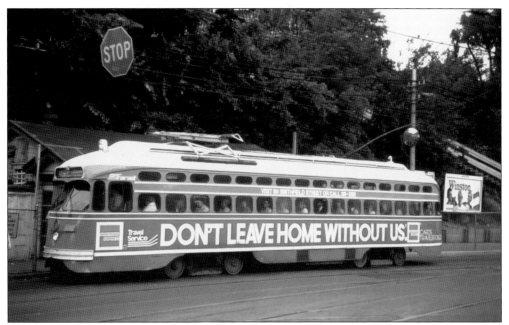

South Hills Junction station stop is the scene for Presidents' Conference Committee car No. 1724 on a southbound trip on route 42/38, on June 19, 1982. This Port Authority Transit advertising car had a white roof, orange upper section around the standee windows, red section around the main windows, and blue lower section with white letters. (Photograph by Kenneth C. Springirth.)

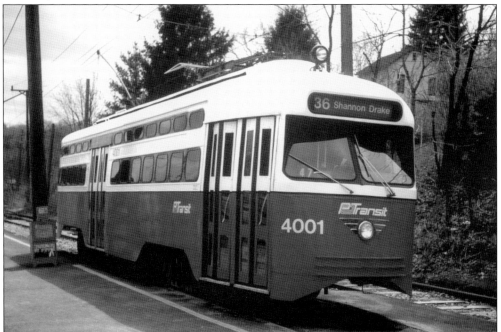

Car No. 4001 (originally car No. 1720) is at Castle Shannon on April 16, 1983. This was the second car extensively rebuilt by Port Authority Transit. The first car rebuilt was No. 4000, which began its test runs on July 30, 1981. About a dozen of these cars were rebuilt, but because of the costs involved, the rebuilding program did not continue. (Photograph by Kenneth C. Springirth.)

April 16, 1983, finds Presidents' Conference Committee car No. 1713 on Liberty Avenue at Seventh Avenue in downtown Pittsburgh. In 1980, Port Authority Transit repainted this trolley into "the Terrible Trolley" to honor the Pittsburgh Steelers football team victory in the Super Bowl. The car featured a black front and rear, with a yellow stripe down the front and center sections of the car. (Photograph by Kenneth C. Springirth.)

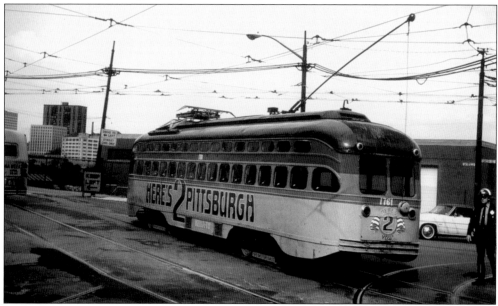

Colorful Presidents' Conference Committee car No. 1761 heads north to downtown Pittsburgh on Smithfield Street, crossing Carson Street, on June 2, 1983. The Port Authority Transit advertising paint scheme has returned to the horizontal striping, instead of the vertical sections of the special car paintings introduced during 1972. (Photograph by Kenneth C. Springirth.)

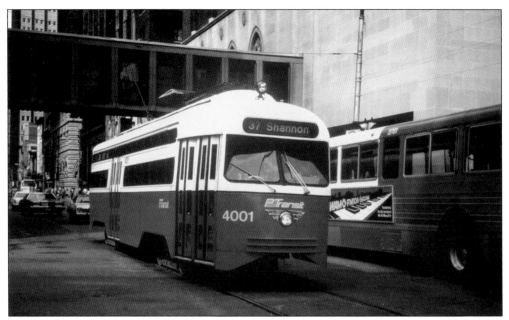

The afternoon rush hour of June 2, 1983, finds Presidents' Conference Committee car No. 4001 southbound on Wood Street, ready to cross the Boulevard of the Allies. This was the second car rebuilt by Port Authority Transit. The paint scheme was white upper section and roof and red lower body section, which was similar to the simplified paint design of Pittsburgh Railways Company back in 1960. (Photograph by Kenneth C. Springirth.)

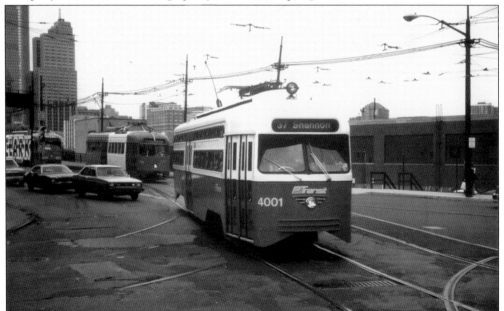

Presidents' Conference Committee Car No. 4001 for route 37 Shannon heads the convoy of trolley cars on Smithfield Street crossing Carson Street, heading south from downtown Pittsburgh on June 2, 1983. Heavy rush hour traffic at this intersection could delay service, but the Mount Washington Trolley Tunnel and large amount of private right-of-way made it possible to usually avoid any further delays in the schedule. (Photograph by Kenneth C. Springirth.)

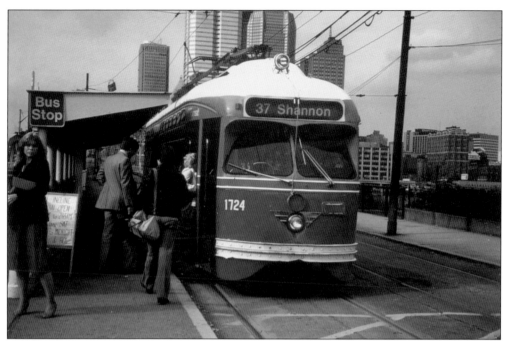

Station Square is a busy passenger-loading point for Presidents' Conference Committee car No. 1724 on Port Authority Transit route 37 Shannon on June 2, 1983. With the downtown Pittsburgh skyline in the background, this trip headed south to Castle Shannon, which was a cutback loop for route 35 Library and route 36 Drake that was used at rush hours and on Saturday afternoons. (Photograph by Kenneth C. Springirth.)

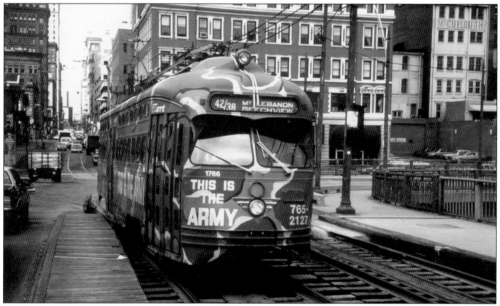

Car No. 1766 has just turned off Fort Pitt Boulevard in downtown Pittsburgh and is heading south on Smithfield Street in military colors on June 2, 1983, declaring, "This Is the Army." The car was on the approach way of the Smithfield Street Bridge over the Monongahela River, heading south on Port Authority Transit route 42/38. (Photograph by Kenneth C. Springirth.)

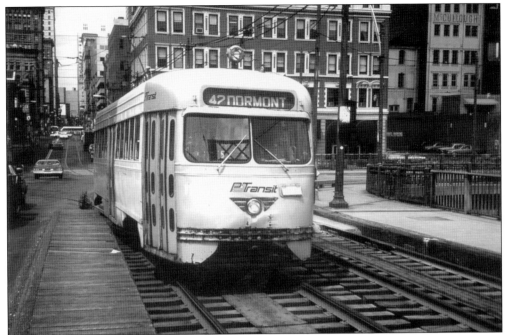

Presidents' Conference Committee car No. 1786 is southbound on Port Authority Transit route 42, on the approach way to the Smithfield Street Bridge just south of Fort Pitt Boulevard on June 2, 1983. This car was originally No. 1643 and had a yellow front and rear section and white center section. All of the trolley routes passed through this intersection. (Photograph by Kenneth C. Springirth.)

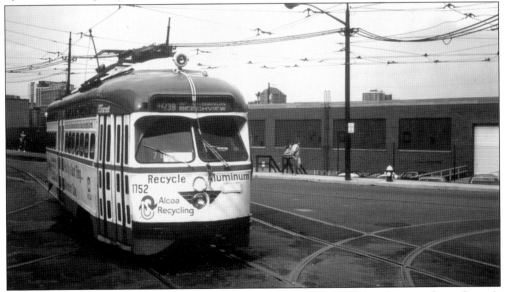

Smithfield Street at Carson Street finds route 42/38 car No. 1752 heading south on June 2, 1983. A pantograph had been mounted on the car roof. Hall Industries of Pittsburgh built and supervised the installation of pantographs on Port Authority Transit trolleys. By the end of September 1983, almost all of the 1700 series cars were equipped with pantographs. (Photograph by Kenneth C. Springirth.)

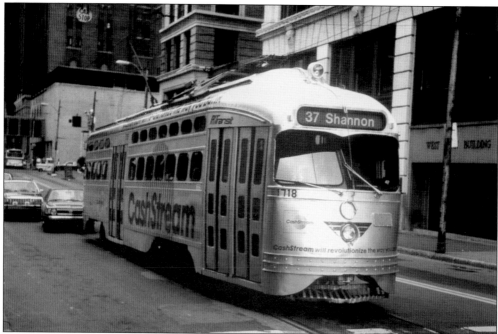

Presidents' Conference Committee car No. 1718 is on Wood Street having crossed First Avenue and is approaching Fort Pitt Boulevard on June 2, 1983. This car was painted silver with blue lettering. The new pantograph on the car roof was a folding arm with a bar on top that contacted the overhead wire to collect electricity for transmission to the car motor. (Photograph by Kenneth C. Springirth.)

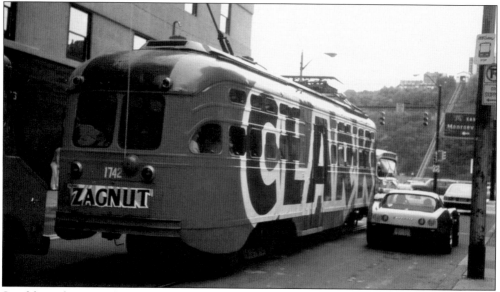

Southbound on Wood Street, ready to turn left on Fort Pitt Boulevard, is Presidents' Conference Committee car No. 1742 on June 2, 1983. The car was painted red with white and blue lettering. A pantograph had been installed on the roof. On Monday, December 5, 1983, car No. 1765 was the first trolley car to operate on the new light-rail transit rails to South Hills Village. (Photograph by Kenneth C. Springirth.)

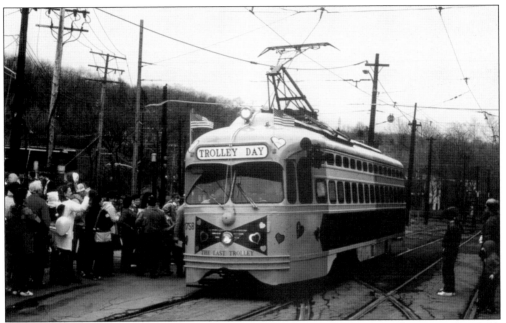

Car No. 1758 is at Clearview Loop on route 42/38 Mount Lebanon–Beechview on April 14, 1984, the last day of trolley car operation on Washington Road. Port Authority Transit shut down the line to permit construction of a new 3,000-foot-long tunnel beneath Washington Road from Shady Avenue to McFarland Road. This line reopened on May 22, 1987, as a new light-rail system. (Photograph by Kenneth C. Springirth.)

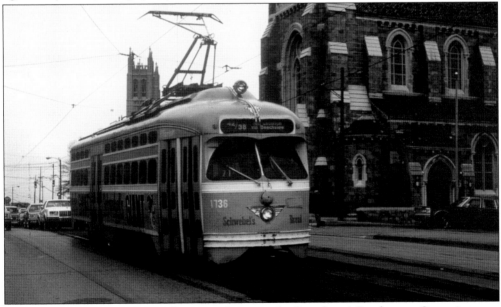

Washington Road in Mount Lebanon is the scene for Presidents' Conference Committee car No. 1736 on April 14, 1984. This was the final day of trolley car operation on Washington Road to permit the construction of a new trolley tunnel. Port Authority Transit painted this bread-advertising car gold with white horizontal striping. Pantograph operation had replaced use of the conventional trolley pole. (Photograph by Kenneth C. Springirth.)

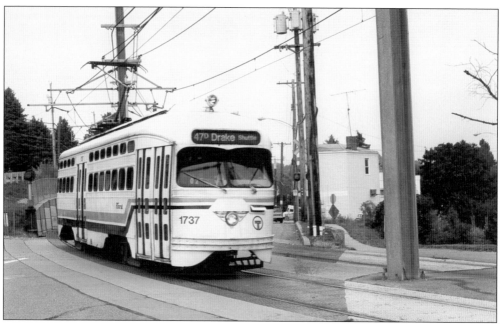

Southbound Presidents' Conference Committee car No. 1737 glides through Martin Villa on route 47D Drake Shuttle on August 25, 1993. Port Authority Transit discontinued service on the Overbrook line because of deteriorated bridges on June 6, 1993, and provided a shuttle operation between Castle Shannon and Drake Loop. Passengers transferred to the route 42L or 42S at Castle Shannon or Washington Junction to travel to or from Pittsburgh. (Photograph by Kenneth C. Springirth.)

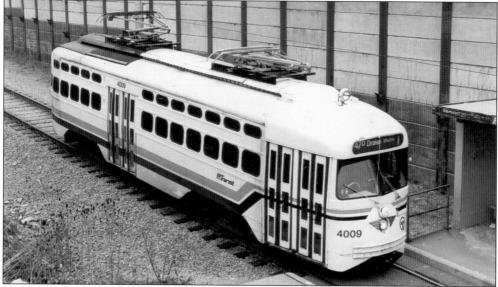

Presidents' Conference Committee car No. 4009 is southbound at Fort Couch Road on route 47D Drake Shuttle on March 26, 1995. With closure of the Overbrook line between Castle Shannon and South Hills Junction on June 6, 1993, Library line cars were designated route 42L and operated via Beechview. Route 42S operated from South Hills Village via Beechview. Route 52 Allentown was the tunnel bypass route. (Photograph by Kenneth C. Springirth.)

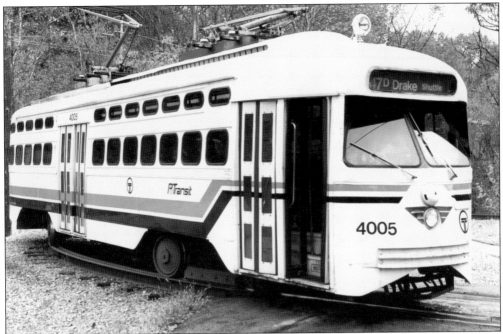

Drake Loop is the layover point for Presidents' Conference Committee car No. 4005 on route 47D Drake Shuttle on October 28, 1995. This line operated to Washington, Pennsylvania, but was cut back to Drake Loop on August 29, 1953, and designated route 36 Shannon-Drake. On June 6, 1993, when service was discontinued on the Overbrook section, it became a shuttle from Drake to Castle Shannon. (Photograph by Kenneth C. Springirth.)

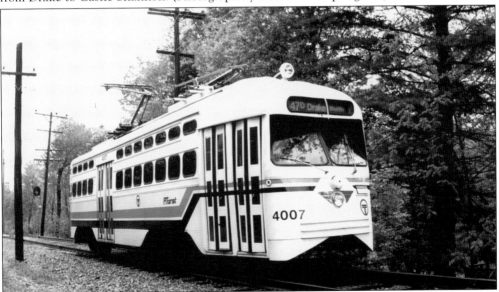

Presidents' Conference Committee Car No. 4007 is north of Drake Loop northbound to Castle Shannon on route 47D Drake Shuttle on May 25, 1997. In the final two years of operation on this shuttle, ridership dwindled to about 50 passengers per day. Port Authority Transit operated one car on the line, with a service frequency of about every 40 minutes. (Photograph by Kenneth C. Springirth.)

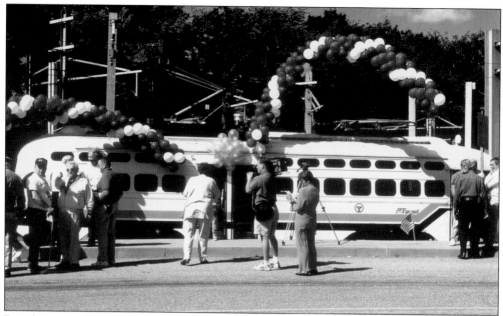

Presidents' Conference Committee trolley car No. 4004 (originally car No. 1739) is displayed at Castle Shannon on August 30, 1999, as the Port Authority Transit announced the end of Presidents' Conference Committee trolley car operation in Pittsburgh. These cars had been confined to the route 47D Drake Shuttle, which operated from June 6, 1993, to September 4, 1999. (Photograph by Kenneth C. Springirth.)

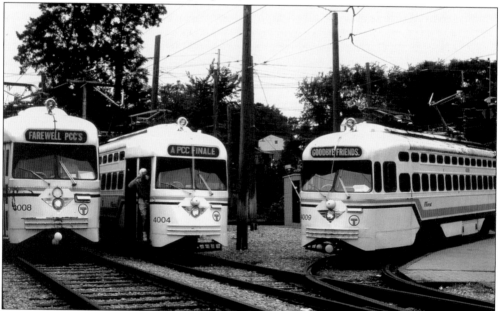

The last three Presidents' Conference Committee trolley cars are at Simmons Loop in the Library section of South Park Township on September 5, 1999, during the Pennsylvania Trolley Museum's final excursion trip with these cars. Port Authority Transit made an excellent contribution to transit history by having these last three cars available for that excursion. Regular service with these cars ended on September 4, 1999. (Photograph by Kenneth C. Springirth.)

Five

RECONSTRUCTION TO LIGHT-RAIL TRANSIT

Official groundbreaking for the new 1.1-mile downtown Pittsburgh subway was on October 19, 1981. The first section of trolley line to be rebuilt to light-rail transit was from Castle Shannon south to Dorchester, with a new line built to the South Hills Village Shopping Mall. Following a three-day opening celebration, the new downtown subway opened on July 7, 1985. There were 55 new light-rail vehicles Model SD400 built by Siemens Transportation Systems and completed on November 25, 1986. These cars were 25.81 meters long over couplers, 2.65 meters wide, 39,000 kilograms empty weight per car, and had a maximum of operating speed of 30 miles per hour. Passenger capacity was 62 seated and 216 standing. Groundbreaking for the rebuilding of the Overbrook line was on April 12, 2000, for the $115.8 million project. The old single-track segments were replaced with double track, and 22 station stops were consolidated into 8 platform stations. A new overhead catenary network was installed to accommodate the modern light-rail vehicles. The reconstructed Overbrook line opened on June 2, 2004, and 28 additional light-rail vehicles were obtained from Construcciones Y Auxiliar de Ferrocarriles S.A. (CAF), which is headquartered in Beasain, Spain. The car body of the new car is self-supporting, Corten cast steel construction. Each car unit consists of two cars with an articulation joint between each other. Passenger capacity is 62 seated and 202 standing. The length over couplers is 25.81 meters, width is 2.674 meters, weight is 44,900 kilograms, and maximum car speed is 48 miles per hour. The 55 original light-rail vehicles are currently being rebuilt by CAF. Only the body shell and doors will be retained in the process. All other components will be new and consistent with components used in the 28 new light-rail vehicles built by CAF. Port Authority Transit is planning a North Shore Connector project that will extend the current 25-mile light-rail system by 1.2 miles from the current Gateway subway station under the Allegheny River in twin bored tunnels to a station near PNC Park and the final station along Allegheny Avenue near Heinz Field. It will terminate near the West End Bridge.

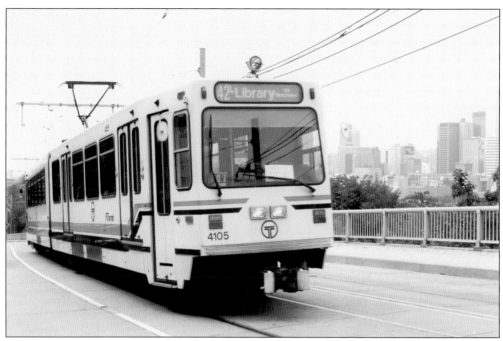

Part Authority Transit car No. 4105 is southbound on Arlington Avenue and William Street on July 25, 1993, with the downtown Pittsburgh skyline just to the right of the car. While work was being done on the South Hills Tunnel, all light-rail vehicles were being rerouted over the Warrington Avenue–Arlington Avenue line, which serves as a bypass route from downtown Pittsburgh to South Hills Junction. (Photograph by Kenneth C. Springirth.)

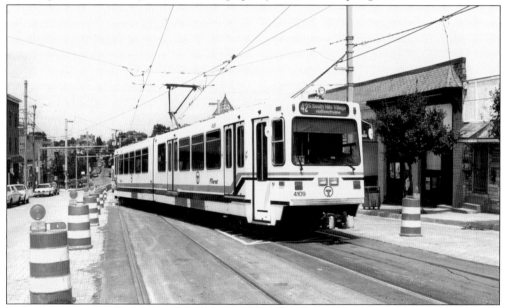

Rebuilding track on Broadway Avenue, near Hampshire Avenue, finds northbound route 42S car No. 4109 crossing over to the southbound track on July 30, 1995. This was a major project to upgrade the street-running trackage, which was used by route 42S South Hills Village via Beechview and route 42L Library via Beechview. (Photograph by Kenneth C. Springirth.)

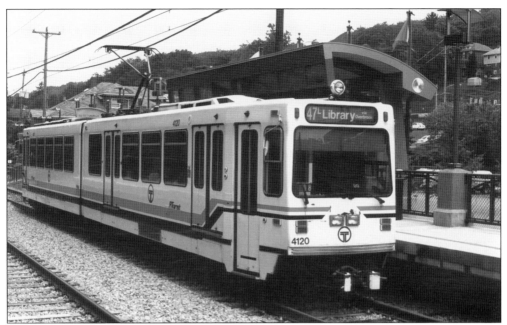

Seen here is the Port Authority Transit car No. 4120 at Killarney Station on June 6, 2004, on the new reopened Overbrook light-rail line. Beginning June 2, 2004, route 42L cars were designated route 47L and were restored to their original routing via the new Overbrook line, between South Hills Junction and Martin Villa. (Photograph by Kenneth C. Springirth.)

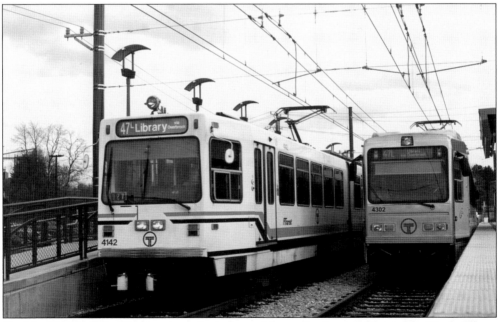

Car No. 4142, built by Siemens, is ready to depart Library Station northbound for Pittsburgh on route 47L on November 2, 2004. Car No. 4302, built by CAF, has just pulled into Library Station. One of the distinguishing features of these cars is that the Siemens car has the headlight on the roof, while the CAF car has the headlight recessed just above the front window. (Photograph by Kenneth C. Springirth.)

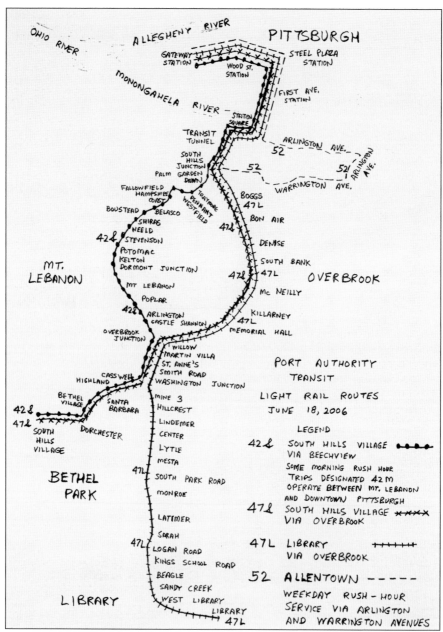

Text labels within the map:

OHIO RIVER

ALLEGHENY RIVER

PITTSBURGH

GATEWAY STATION

STEEL PLAZA STATION

WOOD ST. STATION

MONONGAHELA RIVER

FIRST AVE. STATION

STATION SQUARE

TRANSIT TUNNEL

ARLINGTON AVE.

52

SOUTH HILLS JUNCTION

PALM GARDEN DOWN

52

52 ARLINGTON AVE.

WARRINGTON AVE.

FALLOWFIELD
HAMPSHIRE
COAST

TRAYMORE
PENNANT
WESTFIELD

BOGGS
47L

BOUSTEAD
BELASCO

SHIRAS
NEELD
STEVENSON

BON AIR

42S

47S

DENISE

POTOMAC
KELTON
DORMONT JUNCTION

SOUTH BANK

MT. LEBANON

MT LEBANON
POPLAR

47S

47L

OVERBROOK

McNEILLY

42S

ARLINGTON
CASTLE SHANNON

KILLARNEY
47L

OVERBROOK JUNCTION

MEMORIAL HALL

WILLOW
MARTIN VILLA
ST. ANNE'S
SMITH ROAD
WASHINGTON JUNCTION

PORT AUTHORITY TRANSIT

LIGHT RAIL ROUTES

JUNE 18, 2006

HIGHLAND
CASSWELL

BETHEL VILLAGE
SANTA BARBARA

MINE 3
HILLCREST
LINDEMER
CENTER
LYTLE
MESTA

LEGEND

42S
SOUTH HILLS VILLAGE
VIA BEECHVIEW

42S
47S
SOUTH HILLS VILLAGE
DORCHESTER

47L
SOUTH PARK ROAD
MONROE

SOME MORNING RUSH HOUR TRIPS DESIGNATED 42M OPERATE BETWEEN MT. LEBANON AND DOWNTOWN PITTSBURGH

BETHEL PARK

47S
SOUTH HILLS VILLAGE
VIA OVERBROOK

LATIMER
SARAH

47L LIBRARY
VIA OVERBROOK

47L
LOGAN ROAD
KINGS SCHOOL ROAD
BEAGLE
SANDY CREEK
WEST LIBRARY

52 ALLENTOWN

LIBRARY

LIBRARY
47L

WEEKDAY RUSH-HOUR SERVICE VIA ARLINGTON AND WARRINGTON AVENUES

This map and the June 18, 2006, Port Authority Transit schedules show four light-rail transit routes. Route 42S South Hills Village via Beechview operates frequent rush hour service, and midday service on weekdays is every 12 minutes. Early evening service is every 20 minutes, and late evening service is every 30 minutes. Saturday service is every 14 minutes, and Saturday evening service is every 28 minutes. Sunday service is every 19 minutes, and Sunday evening service is every 30 minutes. Route 47S South Hills Village via Overbrook operates weekday rush hours every 14 minutes. Route 47L Library via Overbrook operates every 14 minutes during weekday rush hours. Midday service on weekdays is every 20 minutes. Weekday evening service is every 30 minutes. Saturday service is every 28 minutes. Sunday service is every 50 minutes. Route 52 Allentown has five morning and four afternoon weekday rush hour trips.

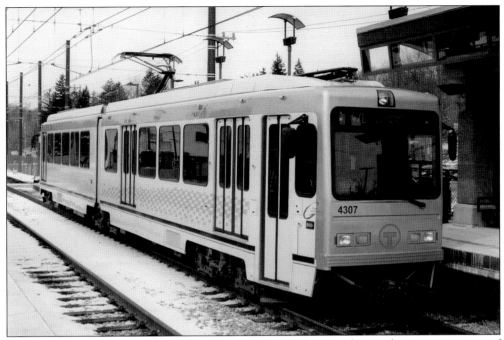

Port Authority Transit car No. 4307 poses at Library Station, the southern most station of Pittsburgh's light-rail system, on March 4, 2005, with a light dusting of snow on the ground. The car built by CAF has three high-platform doors on each side, and there is a street level door at each end of the car opposite the operator. (Photograph by Kenneth C. Springirth.)

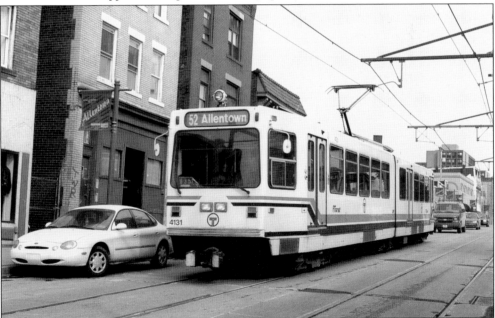

Car No. 4131 is heading westbound for South Hills Junction on East Warrington Avenue near Beltzhoover Avenue, in the Allentown section of Pittsburgh, on March 4, 2005. Route 52 Allentown is a tunnel bypass route that as of the November 20, 2005, schedule operates five morning rush hour trips and four afternoon rush hour trips. (Photograph by Kenneth C. Springirth.)

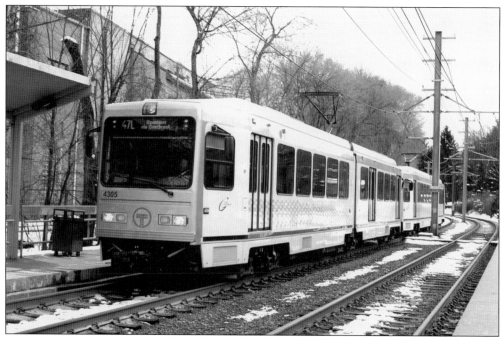

A route 47L two-car train, car Nos. 4305 (first car) and 4303 (second car), is heading northbound to Pittsburgh, passing St. Anne's stop in Castle Shannon on March 4, 2005. Two-car trains are used during rush hours. There is no operator on the second car, and the second car opens its doors only at selected high-level platform stations. (Photograph by Kenneth C. Springirth.)

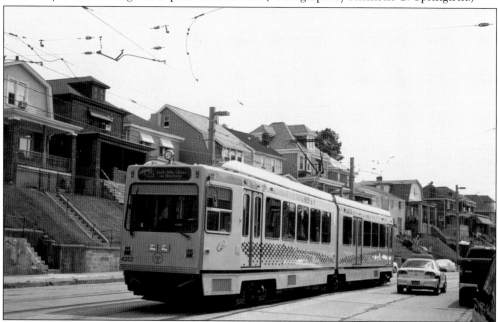

Route 42S car No. 4202 is heading south on Broadway Avenue near Belasco Avenue in the Beechview section of Pittsburgh on June 30, 2006, on an early afternoon trip to South Hills Village. Originally built by Siemens, this car has been rebuilt by CAF to be compatible with the 28 new cars built by CAF. (Photograph by Kenneth C. Springirth.)

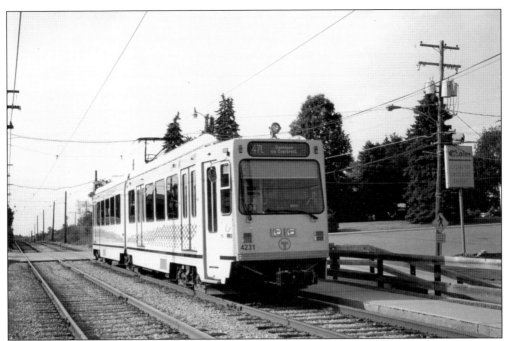

Port Authority Transit car No. 4231 is at Mesta stop heading north to downtown Pittsburgh on route 47L Library on June 30, 2006. This car was originally built by Siemens and has been rebuilt by CAF. The Siemens-built cars will retain the roof headlight, which is the way to differentiate from the CAF cars, which have the front headlight, recessed above the front window. (Photograph by Kenneth C. Springirth.)

Route 47L car No. 4316, heading south to the borough of Library, glides by the Center Street stop in the borough of Bethel Park in the late afternoon of June 30, 2006. The sign reading "Trolley Beautification Committee and Rotary Club of Bethel Park" displays the pride residents have with planting flowers at trolley stops in the borough of Bethel Park. (Photograph by Kenneth C. Springirth.)

www.arcadiapublishing.com

MAP SEARCH

Discover books about the town where you grew up, the cities where your friends and families live, the town where your parents met, or even that retirement spot you've been dreaming about. Our Web site provides history lovers with exclusive deals, advanced notification about new titles, e-mail alerts of author events, and much more.

MADE IN THE **USA**

Arcadia Publishing, the leading local history publisher in the United States, is committed to making history accessible and meaningful through publishing books that celebrate and preserve the heritage of America's people and places. Consistent with our mission to preserve history on a local level, this book was printed in South Carolina on American-made paper and manufactured entirely in the United States.

This book carries the accredited Forest Stewardship Council (FSC) label and is printed on 100 percent FSC-certified paper. Products carrying the FSC label are independently certified to assure consumers that they come from forests that are managed to meet the social, economic, and ecological needs of present and future generations.

FSC
Mixed Sources
Product group from well-managed
forests and other controlled sources

Cert no. SW-COC-001530
www.fsc.org
© 1996 Forest Stewardship Council

Find Your Place in History.